SURVIVING THE WINTER

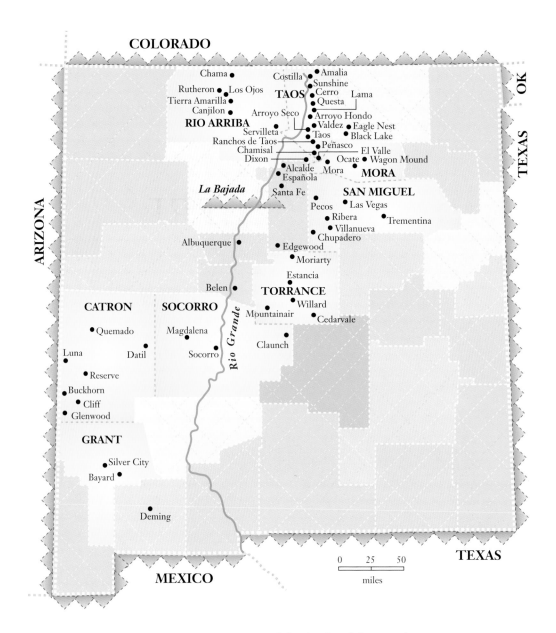

COLORADO

OK

TEXAS

ARIZONA

Chama
Costilla • Amalia
Sunshine
Rutheron • • Los Ojos Cerro
TAOS Questa • Lama
Tierra Amarilla
Canjilon Arroyo Seco Arroyo Hondo
RIO ARRIBA Valdez • Eagle Nest
Servilleta Taos • Black Lake
Ranchos de Taos Peñasco
Chamisal El Valle
Dixon Ocate • Wagon Mound
Alcalde Mora
Española MORA
La Bajada
Santa Fe SAN MIGUEL
Pecos • Las Vegas
Ribera Trementina
Villanueva
Chupadero

Albuquerque • Edgewood
Moriarty
Estancia
Belen • TORRANCE
Willard
CATRON SOCORRO
Mountainair Cedarvale

Quemado Magdalena
Claunch
Luna Datil Socorro

Reserve

Buckhorn
Cliff
Glenwood

GRANT

Silver City
Bayard

Deming

TEXAS

Rio Grande

MEXICO

0 25 50
miles

Map by Carol Cooperrider

SURVIVING
THE
WINTER

THE EVOLUTION OF QUILTMAKING
IN NEW MEXICO

Dorothy R. Zopf

UNIVERSITY OF NEW MEXICO PRESS
ALBUQUERQUE

Library of Congress Cataloging-in-Publication Data

Zopf, Dorothy R., 1928–
 Surviving the winter : the evolution of quiltmaking in New Mexico /
by Dorothy R. Zopf.—1st ed.
 p. cm.
 ISBN 0-8263-2242-5 (cloth : alk. paper) —ISBN 0-8263-243-3 (paper :
alk. paper)
 1. Quilts—New Mexico. I. Title.
 NK9112 .Z67 2001
 746.46'09789—dc21

 00-009688

Printed in Hong Kong by C & C Offset Printing Co., Ltd.

CONTENTS

ILLUSTRATIONS

Surviving the Winter

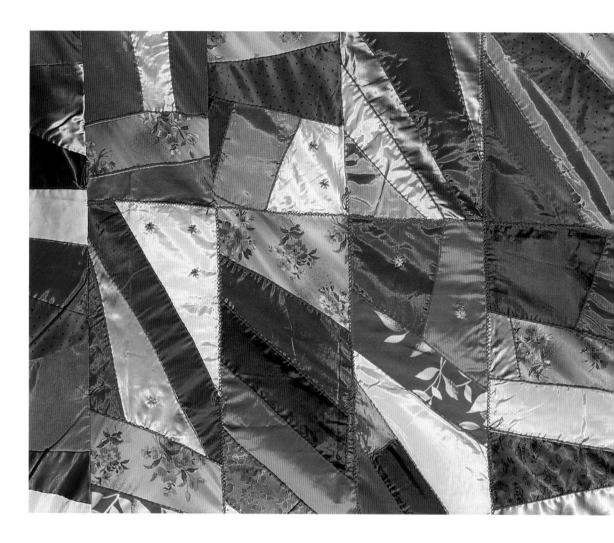

FIESTA CRAZY
*Made from old fiesta clothes. There were nine
girls in the Aguilar family and so Irene learned
to embroider in order to put their names on
their dresses. Irene Aguilar Mercure, Rutheron,
New Mexico, 1974, 53 x 63 inches. Photo by
Willi Wood.*

Chapter 1

WHY AND HOW

In only fifteen years, from 1981 to 1996, the two square miles of northern New Mexico territory between my house and the Arroyo Seco Post Office have changed so drastically that it suddenly has become imperative for me to try to record an older way of life before it becomes totally obliterated.

Farm and pastureland is being subdivided. Llamas and geese, definitely nonsubsistence creatures, are replacing cattle and sheep. No longer can I anticipate meeting a hog along the road bent on finding the food of his dreams outside his own pen: today someone would call the sheriff. Fifteen years ago a neighbor would have met the news with a philosophical shrug and words to the effect that it is better to roam and eat than to stay home and starve. The community was expected, where possible, to do its part.

My husband George and I retired here from Ohio in 1981, twenty years after our first glimpse of the Sangre de Cristo Mountains while on a summer vacation. "This is where we're coming when I retire," he

informed me. I was too young then to take his declaration seriously. It wasn't until 1975, when his determination still had never wavered, that I insisted he spend a winter in northern New Mexico. I was certain he would be cured and our life in Ohio near our children and old friends could continue uninterrupted. Instead, that year my husband spent teaching science at Questa High School was the last nail in my coffin. We bought land north of the town of Taos, near the Pueblo, and went back to Ohio to wind up affairs. We returned in the summer to drill a well, then another summer for George to attend adobe construction school.

My resistance to his plan remained strong. I vividly remember one blistering hot July day driving west across Kansas when I announced that I would not go another mile. George cajoled me with the sure promise that it would be cool in the mountains, and of course he was right. The climate is dry and always cool in the shade. The mountains loom and recede, changing color every hour

of the day, every season of the year. During the last fifteen years I've learned that landscapes need not necessarily be green to be beautiful. Great rocks and boulders, gashes in the earth, canyons and sagebrush beneath vivid blue sky, and ever-changing clouds are always beckoning me to look again.

I had retired in 1980 from many years as a high school art teacher, expecting to settle back comfortably in familiar surroundings. Instead, being the "social" partner, I became the contractor for our 800-square-foot adobe home. A dedicated son-in-law, two nephews, and a couple of local boys who were in training to play football comprised our building crew, directed by my husband who doubled as carpenter. My sister had a warm meal waiting each evening. We moved in on October 15, 1981. It snowed the next day.

That fall of 1981, and for many years thereafter, I walked the two miles to the post office in hope of a letter from one of our four children, literally and figuratively a thousand or more miles away. I was in an unfamiliar world. The hard-packed dirt of the yards around the small adobe houses was swept clean, not planted in grass. There were a few mobile homes, but more would come soon. There was also the *camposanto* (cemetery), which was the most colorful place on my entire walk. It was filled with bright flowers, both plastic and real, flags, and balloons on the anniversary of a death. The homemade crosses and low fences around each plot were painted in vivid colors. This wasn't my Ohio world.

Always before when we had moved, I had kept up an enthusiastic front because of the children. It became a habit to say that each new place was better then the last. Now, with the frantic activity of building over, with no children to buoy up, and a husband who didn't leave for work each day, I collapsed into tears. My life seemed purposeless. The few quilts I made that first winter—I've always made quilts—were predominantly black.

A notice in the weekly newspaper of a Christmas tea and display of local crafts in the old church building in Arroyo Seco finally piqued my interest. The bell tower of that building had always been a landmark for my walks—the new church built in 1965 is much larger, but hidden by trees—and I was curious to see the interior of the old adobe building. There are only two windows, set high above the interior sills, where two parishioners crouched on lookout for marauding Utes or Apaches in the early days of the 1846 building. Apparently only three members of the original congregation owned adzes, the tools used to carve the decorative corbels for the great *vigas* (beams) of the ceiling; I surmise this because there are three interpretations, each repeated many times, of the standard step-and-curve design of a corbel. The church has been remodeled several times over the years, but the windows and the corbels remain unchanged.

That Christmas of 1981 the local women giving the tea were weavers and quilters. The walls of the sanctuary were hung with wool and cotton rag rugs and quilts. Pillows and other smaller items were spread on the big sewing tables. Six looms—big, stand-up, two-harness looms—were draped with more rugs. The altar had been converted into a buffet of punch and cookies. They welcomed me, this woman who had been walking silently to the

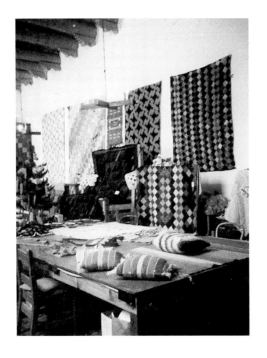

Christmas party in the old Church of the Holy Trinity building. Note the variety of corbels at the ends of the vigas (beams). Arroyo Seco, New Mexico, 1982. Photo by the author.

post office so many months, and, after reciprocating smiles, I was invited to come there to work on my own quilts, to have a place among peers, every Tuesday for the next ten years. Thus I joined Pearl Martinez, Casimira Madrid, Ida Martinez, Mabel Read, Precides Martinez, Teresa Archuleta, Viola Varos, Margaret Woodall, and Priscilla Cruz.

Although Spanish was the language of choice, most of the women were bilingual and made translation for me seem effortless. An older weaver, who spoke no English, was a superb storyteller. With Pearl at my elbow, in case of the need for a word or two, Casimira, after lunch, would begin to flutter her hands, roll her eyes, and we knew that it was story time. All her life, ninety-three years in 1996, Casimira had never lived more than a mile from that church. This day she was talking about the church before it had a wooden floor. She looked straight at me and

pointed her finger downward; then her hands began to outline the bodies that were interred in that dirt under the floor. Fear of wild animals desecrating the graves, she positively snarled, had made the people bury their dead inside the building in the early years. Now, with her hands moving in circles, we knew that those ancestors were still watching under us, keeping everything snug and secure.

I learned lesson after lesson. What I had known as one of the miracles of the New Testament, feeding the multitude with only a few "loaves and fishes," was re-enacted for me weekly with whomever happened to be in the building. Nobody else had a neat little sandwich in a tightly folded brown paper bag. They brought the remains of a box of crackers or a loaf of bread, a can or two of sardines or Vienna sausages, some roasted green chiles or a jar of red pureed chile, plus

a few cents to go into the coffee fund. We shared. I learned to cut up a sandwich into eight or ten pieces, to eat tamales and wild spinach. They taught me to find asparagus along the ditches and I showed them how to cook up milkweed buds for a spring treat. We all made pie after pie from the apples and apricots picked in the fall. We did a lot of sharing and a lot of laughing. In Ida's words, "We had a ball."

I also learned that there are as many ways to make a quilt as there are people who make them. My grandmother in New Jersey had used new cotton fabrics left over from dressmaking; she used a template to mark every piece and she pieced by hand. Suddenly that technique was long ago and far away. In the old church our fabric was donated used clothing, often left after a garage sale. What was really good went to Mexico for relief work. The knits were set aside for the weavers to make rag rugs. The rest was divided according to color, not fiber, into big plastic bags for the quilters. The predominant color in a print determined the appropriate bag. Sewing machines, electric scissors that rarely worked, squares cut by folding— any technique that would help us keep even marginally ahead of those bags-full was welcomed. I eventually used a paper cutter to make the strips for innumerable Log Cabin variations; the fabric was trimmings from the bottoms of men's trousers carefully saved for us by the alterations department of a men's clothing store. Once in a while we quilted; more often we tied. The quilts and woven rugs were used as family gifts or sold to keep the building heated and in repair.

When that building, *La Iglesia de la San-tisima Trinidad* (Church of the Holy Trinity), was condemned in 1989, I knew that something had to be done to record a traditional way of life that was not unique to my two square miles, but was disappearing all over rural New Mexico. I was inspired by a quilt historian, Jeannette Lasansky, who had been hired by the Museum of International Folk Art in Santa Fe in 1986 to spend six weeks in New Mexico driving the length and breadth of the state collecting stories and quilts typical of the regions. Her tour began in La Iglesia de la Santisima Trinidad and she returned there at the end to make a short film for television. Her stories and enthusiasm suggested to me that quilting could be my vehicle for recording the ways of rural life in New Mexico.

With an invitation to present the story of rural quiltmaking in Taos County, and the promise of $300 from the Franklin & Marshall College Symposium to be held in 1993, I began, in 1991, to collect data. The home demonstration agent of the county extension office was my liaison with Taos County quiltmakers. She alerted the clubs while I prepared a one-page questionnaire and snared an unsuspecting photographer friend, Willi Wood, plus Ida Martinez, who was fluent in Spanish. We drove off, that first time, to the Chamisal Senior Center to photograph the quilts and their makers and to collect the questionnaires they had filled out. It seemed simple, but it proved too windy to photograph outside, so we took down curtains and held the quilts inside, opposite the window. Most of the makers had been too modest or not fluent enough in English to fill out the questionnaires, but one helped another as the

CRAZY
Lucia put the hit-and-miss scraps together on
squares of old sheet. Lucia Lopez, Questa,
New Mexico, 1964, 56 x 70 inches.
Photo by Willi Wood.

The senior center in Chamisal on quilt survey day. Chamisal, New Mexico, 1991. Photo by Willi Wood.

time flew by and the refreshments, Jell-O and cake, began to sag. There were so many quilts. I had made no provisions for narrowing them to a workable number. In fact, in fear that there would be too few quilts, I had offered a $50 prize for the most quilts, $30 for the second most, and $20 for third place. First prize went to Josepha Rodriquez, who brought twenty-six quilts and would have gone home for twenty-six more if anyone had challenged her supremacy. Shortly thereafter I began giving five dollars to everyone who came, plus a dollar per quilt, because everyone deserved recognition. I also learned to scan the number of quilts piled up and to select an appropriate number from each quiltmaker; sometimes that was all of the quilts and sometimes it had to be limited to four or five per contributor. Despite the hurdles, the experience in

Chamisal had been the most exhilarating of my life.

When the survey team pulled up at the senior center in Willard it was only 8:00 a.m., but things were already bustling. The center, comfortably furnished with the proceeds from special breakfasts, is next door to the post office. People collect their mail and then stop in for a cup of coffee and to find out what's going on that day. One man hurried right out to tell his wife that we were really there. Another quiltmaker sent her grandson to check the schedule. Later in the morning two little girls, ages 10 and 12, appeared with a quilt made by their grandmother. When we presented them each with five dollars for coming plus one dollar for bringing one quilt, they ran back home and each pulled a grandma quilt from her bed and brought it in to be recorded.

RED DOTS
"The patch is yellow because I didn't see it was a flag until today! My sister made it." Eumelia Gonzales, San Juan, New Mexico, 1969, 79 x 92 inches. Photo by the author.

A new career had unfolded. Friends who are quilters, and other friends who are writers, have become the scribes. They include Mary Alexander, Lorraine Ciancio, Kay Giddens, Joan Loveless, Ida Martinez, Joan Phillips, Marjorie Reading, Lore Ribas, Aurelia Scott, and Susan Thomason. Usually three or four of them go with me on a trip. The scribes ask leading, and pleading, questions to draw out the shyer women. The questionnaires have been revised several times in order to gather specific, calculable data. Willi has continued as photographer, with Kerry Heubeck as backup. One of the scribes is assigned to keep the photo log and to take a quick snapshot with another camera (in addition to the professional slides) to ensure a pictorial record of every quilt. The snapshots are later attached to the data sheets. We use a long piece of cleaned and painted rebar with spring clips to hold the quilts for picture taking outdoors, but when the wind is really blowing it still takes two or three of us to hold things in place. The quiltmaker, who has stepped out prettily to have her picture taken, is often commandeered to hold up an end of the rebar or to bend down to grab a fluttering quilt corner for the next participant.

My speech at Franklin & Marshall College was originally to cover only Taos County, six

STRING QUILT
The blocks are pieced from narrow strips,
making this a string quilt. Elvira Cisneros,
Questa, New Mexico, c. 1930, 68 x 86 inches.
Photo by Willi Wood.

locations in all, but the team was having so much fun and learning so much about a land that was native to none of us that nobody wanted to stop, least of all me. Making and selling my own quilts became our source of income after the initial $300 was spent. But if we were to travel much farther, meals and motel rooms would have to be considered. I applied for and received the Laura Bettens Research Foundation Grant for 1993. Off we went to Mora County. It felt so good to be able to buy the photographer's film, not to mention lunches for the team. That money spent, we started on to San Miguel County anyway, despite motel costs. Further grant applications proved fruitless. Each team member now pays her own way. My quilt sales cover gasoline, the five- and the one-dollar gifts, and the book—a compilation of retyped information sheets with a picture of each quilt—that is then donated to the appropriate county or community library.

The home demonstration agents have continued to be a fine resource, especially in setting up meeting places. Word-of-mouth has been invaluable. The contact person in the distant county is responsible for advertising the event. It has really been an experience in cooperation and faith. The voice I hear over the telephone materializes, when we meet, into yet another enthusiastic person; Linn Kennedy of Datil even fed the four of us dinner because, as she said, "There really isn't much of any place to eat out here."

My own town of Arroyo Seco, Taos County, New Mexico, boasts a population of only 700. Most of the communities we've visited have fewer than a thousand people, and this was the scale of the tradition that I wanted to document. These are sleepy towns settling back into memories. Most of the mercantile establishments have closed shutters. Older adobe homes have boards across the windows. But one spot is always bustling: the senior center, or its equivalent, the community center, often the old schoolhouse abandoned when the districts were consolidated.

It has been an adventure in ingenuity. The volunteer team has pushed and pulled on windy days, tugged and snared quilts into position for the camera, worried that no one would come, and then slumped over exhausted at the end of the day, having seen and heard so much. This has been an opportunity to visit along the back roads of New Mexico, to share a narrow highway with deer and antelope, and to crane our necks to see to the tops of the great adobe churches, now in ruins, built in the seventeenth century by Native Americans under the direction of Spanish friars. We've revived ourselves with beer in the tiniest of towns, in places like the Rosebud Saloon in Mountainair and the *cantina* in Magdalena, where the ceiling is festooned with signed dollar bills; an act that assured a prospector one last drink even if he had gone bust. My odometer has registered 3,057 miles of travel over six years. We've seen quilts made of socks and trousers, from new cloth and old, one in the image of an American flag, and others made from satin blouses and fiesta skirts. We've even seen one made from the uniforms of a Blue Angel, a member of the U.S. Naval precision flying unit. Painted and pieced, embroidered and appliquéd, one-patch, string quilts, Crazy quilts, quilted quilts, and tied quilts have boggled our minds. The makers have ranged in age from five to eighty-five; the quilts have dated from 1906 to 1996. It has been a great adventure, an attempt to piece together the story of keeping warm in rural New Mexico.

WOOL STRIPE
*The vigas and latillas of Spanish ceiling
construction are translated into patchwork.
Beatriz Quintana, Cerro, New Mexico,
1950s, 53 x 76 inches. Photo by the
author.*

Chapter 2

HERITAGE AND CHALLENGE

The drive to Villanueva is along the Pecos River beside red sandstone cliffs. The narrow valley is tightly farmed, the river lined with giant cottonwood trees, shady and green. Every four or five miles, up on the high ground, are the remains of towns, once outposts to guard against Indian attack. Our tension, however, came from another source. Would there be any quilts to record in a town of 350 people? Stepping through the doors of the senior center all doubts vanished. There on the far wall of the dining room hung an album quilt with signed blocks representing each member of the center in 1988. When a member dies, a tiny golden cross is pinned to that block. The last survivor gets the quilt.

Quilts made in the rural areas of any part of the United States are a genre unto themselves. They reflect a pattern of hard physical labor—Rusty Mondragon of Wagon Mound told us, "I helped her to farm; she taught me to make quilts"—and of relative isolation, recollected by Thelma Rodgers of Estancia, "I learned how to quilt over the telephone."

New Mexico continues these two traditions and adds a third, the crossing of two cultures: the Anglos with a tradition of quiltmaking, the Spanish-Mexicans without that tradition. The New Mexicans of Spanish descent are unique in that they developed a solution for using scraps of fabric sewn together to make warm coverings for their beds, without having had any previous experience of quiltmaking.

Beginning in 1540 with Coronado seeking the fabled seven cities of gold, the Spanish entered the territory, and, by 1598, permanent settlements were established. These people, originally from Spain but often acculturated in Mexico before heading north, had no tradition of quiltmaking. The Spanish word *colcha*, from the same Latin root *(cucilta)* as our word quilt, means bedcover, and is used to describe a blanket or bedspread. *Quilta* is a more recent Spanglish word.

The immigrants from the south were herders of sheep and weavers of wool and cotton. They did not practice the American

tradition of quiltmaking. It wasn't until 1833 that the first woman from the eastern United States, Mary Donaho, traveled the Santa Fe Trail to settle in the Mexican territory of *Nuevo Mexico*. Sadly, we know nothing of her quiltmaking.

Wool was the most available fiber. Blankets, serapes, and shirts were fashioned without cutting the loomed product. Worn garments were darned or unraveled to be rewoven. In 1540 Coronado brought 5,000 *churro* sheep with him, and again in 1598 Oñate's settlers herded in another 4,000 of the animals. Although originally intended only as food, the sheep thrived on the New Mexico climate and diet and were soon as prized for their wool as for their flesh. Woven blankets and yardage became the chief trade item in the caravans that annually traveled the Camino Real to Mexico.

Leather and wool were the common fabrics of the frontier. By the eighteenth century fancy silk damasks and Indian calicoes were arriving in Santa Fe via Mexico and the Manila galleons, but only for the very rich. The poorer people began to imitate the wealthy by embroidering in wool on wool. They used flowers, birds, vines, and leaves in imitation of the calico paisley. The late nineteenth century brought another design element, the Lemoyne (eight-pointed) Star, a patchwork quilt motif from the eastern United States, which was incorporated into the weaving of the Rio Arriba, northern Rio Grande area, to augment the earlier geometric patterns.

There was simply no quilting tradition among the Spanish-Mexican settlers along the Rio Grande corridor. Not until the coming of the railroad in 1880 and home delivery of mail, including the Sears Roebuck and Montgomery Ward catalogs, were these people confronted with the concept of "scraps" left over from worn clothing and new sewing. Frugal and conservative, they had to find a way to solve the problem of oversupply.

The settlers were used to solving their own problems. In the beginning they had been 5,000 miles from their ruler in Madrid, Spain, and, after the revolution of 1821, were still 1,500 miles from the seat of government in Mexico City. Mail arrived once a year, at best.

Scraps or rags were simply the answer to a problem. They might have been used in ways other than quiltmaking; however, it is very cold in the snowy mountain regions of northern New Mexico. From sheep to finished serape is a long, arduous task. A person who could devise a quicker, easier way to winter warmth was a godsend to the family. Cotton rags are still spun and woven for rugs, but not as blankets for the bed. Piecework could be used to create a new cover for worn blankets.

Approaching the task like a painter, the housewife found herself confronted with an empty space the size of a blanket and an enforced palette of clothing scraps. Familiar with the weaving tradition, it was natural to make long strips assembled from pieces of equal height and various widths laid horizontally and then stitched together, just as one might throw the weaving shuttle from selvage to selvage in order to create a whole cloth from horizontal threads.

Another weaving technique popular in the area was the Saltillo blanket, which contains a central diamond or circle woven in tapestry

LONE STAR
Although made in Farmington, this pattern for a
Lone Star came with the Lackey family from Texas.
Gladys Lackey, Farmington, New Mexico, 1930s,
80 x 80 inches. Photo by Willi Wood.

SQUARES
Isobel spoke only Spanish and, in the old way,
made her quilts of squares running from edge
to edge. Isobel Ulibarri, Tierra Amarilla,
New Mexico, date unknown, 62 x 82 inches.
Photo by Willi Wood.

BANDANNA STRIP
The strips, including white satin pieces from her
son's Communion shirt, are sewn to foundation
squares of old muslin. Erlinda Gonzales, Las
Vegas, New Mexico, 1962, 72 x 90 inches.
Photo by the author.

An old San Juan Pueblo blanket emerging as the fill from a twice-covered whole-cloth quilt still in use in the Villareal family. Elena Villareal, Alcalde, New Mexico, 1925, 47 x 68 inches. Photo by the author.

and later surrounded by a straight-weave background. Some quilt tops are assembled in the same way; that is, begun with one piece of cloth in the center and then added to around and around until the desired finished size is reached.

Rarely are the older quilt tops assembled on the diagonal, just as one rarely sees the twill weave of a four-harness loom where two harnesses are the norm. The backing resembled the top; the fill was either a threadbare serape or more scraps, and all were then tied together, using yarn left from cutting the warp from the looms.

Think what it must have been like for the first Hispanic quiltmakers. No pattern to follow, no traditional criteria for technique, no rules. They were on their own. Was it frightening? Given the two guiding principles of life among the Hispanic people, family and faith, it was probably less frightening than it would be in a more commercially centered society. The finished quilt, whatever its appearance, was a family necessity, not an ornament, and in the all-encompassing faith of the Catholic Church, people were not expected to be perfect, nor were temporal

concerns paramount. As they dress their adobe churches in a new coat of mud plaster each year, so new covers, not new quilts, are made to prolong the life of an older quilt or an even older serape.

Mexican independence from Spain permitted the opening of the Santa Fe Trail and began the slow change of immigration from south-north to east-west. President James Polk's policy of Manifest Destiny led to the occupation of New Mexico territory by the United States in 1847, and fired up adventure-seeking immigrants with dreams of the Southwest. Migration became a pattern, as exaggerated stories drifted from one frontier to the next. Disgruntled forty-niners who recalled passing through the rich, short-grass prairies of eastern New Mexico returned as settlers. Having been posted to a southwestern frontier fort, many U.S. Army troopers retained a vision of New Mexico as either haven or horror. The exploits of Kit Carson were magnified in dime novels even before his death in 1868. It was seen as a land of opportunity.

The coming of the railroad in 1880 accelerated immigration, for then the Southwest

DIAMONDS AND RECTANGLES
A corduroy quilt pieced both front and back,
filled with a sheet-blanket, and tied with
multi-colored yarn. Genoveva Martinez
Varela, Pecos, New Mexico, 1944, 42 x 64
inches. Photo by the author.

CRAZY QUILT
So as not to interfere with the embroidery, this
quilt is tied from the back. F. P. G. and K. N. P.,
Estancia, New Mexico, 1911, 69 x 78 inches.
Photo by the author.

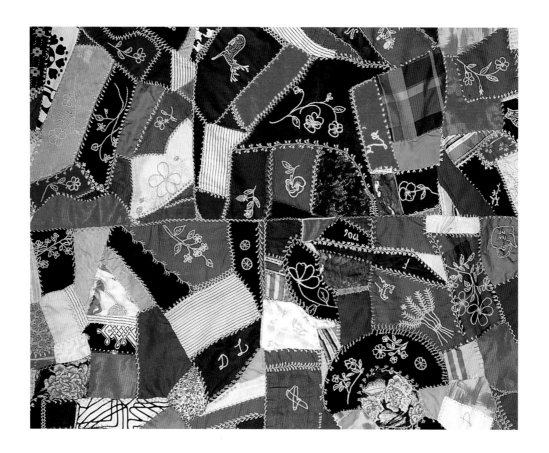

CRAZY
The only tangible record left of a remarkable
woman, this quilt happened to be loaned to a
daughter when Maggie and her house burned
to the ground. Maggie Williams, Moriarty,
New Mexico, 1906, 64 x 74 inches. Photo by
the author.

was perceived as a true extension of the eastern United States, safe for even the most timid.

Families coming from the east brought their quiltmaking traditions with them. An exquisitely embroidered Crazy quilt made in Estancia and dated August 18, 1911, bears witness to the availability of mail-order silks and velvets, patterns, and ideas foreign to the frontier. This quilt was bought at an estate sale and nothing is known about it except what is recorded on the quilt: "Many happy returns of the day, FPG & KNP, Estancia, New Mexico." In every dark swatch, black or burgundy velvet, there is an embroidered picture including symbols of good luck, like a horseshoe or a pre-Nazi swastika, known to Navajo weavers as the Rolling Log. The light patches are cut from patterned silks and satins.

In 1906 a thirteen-year-old girl named Maggie made a different kind of Crazy quilt. Her parents came from Texas to homestead near Moriarty. Unable to attend school and make new friends, Maggie relieved that first winter of pure lonesome misery by using scraps of clothing and thread to embroider a storybook quilt. The pictures in the patches are of the plants and animals Maggie could see from their dugout, a hastily dug basement roofed over to provide shelter until there was time and money to build the house. The embroidery stitches around each patch are different one from another. Maggie explored all of the possible permutations of the featherstitch, added crosses, chains, and daisies, and challenged her imagination.

Eleven years later, Modena Shaw, age 11, came in a covered wagon with her family from Texas to homestead outside Mountainair, a town soon to be known as the pinto bean capital of the world. It was a hard life and no easier after marriage, when she and her husband would, twice annually, cut two wagonloads of wood and haul them forty-one miles to Belen to exchange for groceries, tools, and clothing. If Modena found time in those days to make even the most utilitarian of quilts, we don't know. Her earliest surviving quilt is a fine Postage Stamp made in 1944–45 for her son's wedding. This quilt contains approximately 9,720 postage-stamp-sized pieces of cloth, all pieced by hand in concentric circles of color. She was forty years old and just finding the time to indulge in the fancy quiltmaking tradition remembered from childhood.

Carolyn Wells told us, "My grandpa run the first newspaper in Estancia. He was a newspaperman from Kansas. The quilting came from my grandma's side of the family. Her sisters did beautiful quilting. Their family came from Germany."

The Great Depression brought more homesteaders. Neva Turner recalls that there was no work in Texas, so her family came out to Quemado. "We were only going to stay for maybe three years or until times got better and then we'd go home. Never made it."

Maiden ladies came too. Drucilla Ghann (Seward), a Florida schoolteacher, wanted to see where the Indians lived. She found work teaching school in Gallup, met a handsome cowboy, married him and never left New Mexico.

Beatrice Holley (Mactavish) and her sister arrived in Magdalena from Alabama. Both

POSTAGE STAMP
Made as a wedding gift for her son. Modena
Shaw, Mountainair, New Mexico, 1944–45,
64 x 74 inches. Photo by the author.

CAMPING BLANKET
Before polyester double-knits, men's trousers
provided the sturdiest fabric for an old-way utility
quilt. Beatriz Quintana, Cerro, New Mexico,
c. 1950, 60 x 75 inches. Photo by the author.

were schoolteachers looking for adventure and jobs, and with them came their quilt-making skills.

Free land, short-lived mining booms, adventure seekers, and missionaries all helped to bring the eastern tradition of quiltmaking to New Mexico. They brought the concept of quilts pieced in blocks according to a pre-scribed pattern, the layers then put into the frame and quilted, not tied together.

Over the intervening years, 1880 to the present, two traditions, called utility and dec-orative, have gradually come together, but are still referred to as "old-way quilts" (haphaz-ard) and "new-way quilts" (fancy). An old-way quilt is made in a day, without a prescribed pattern. It usually involves several members of the extended family in cutting, sewing, and tying. The back of the old-way quilt resem-bles the front and there may or may not be a

FRENCH CHAIN
Fidelia never returned to old-way quiltmaking
after trying this new way, fancy, symmetrical
pattern. Fidelia Vigil, Peñasco, New Mexico,
1970s, 72 x 89 inches. Photo by Willi Wood.

filling. A new-way quilt uses templates, a pre-determined pattern, has a plain back, a filling, and is either quilted or tied. These two traditions still exist in New Mexico, although with the proliferation of magazines and television shows about quiltmaking, the making of haphazard quilts is declining.

Eldeene Spears of Taos County, the daughter of one rancher and the wife of another, explained it this way: "My nice quilts are the ones that use a paper pattern and I quilt them. The others, the blue jean and old wool trouser pallets, are tied together."

This, then, is the background of quiltmaking in rural New Mexico, where quilts have helped to meet the inevitable challenges of any frontier: to fulfill immediate needs and to gradually enrich the quality of life.

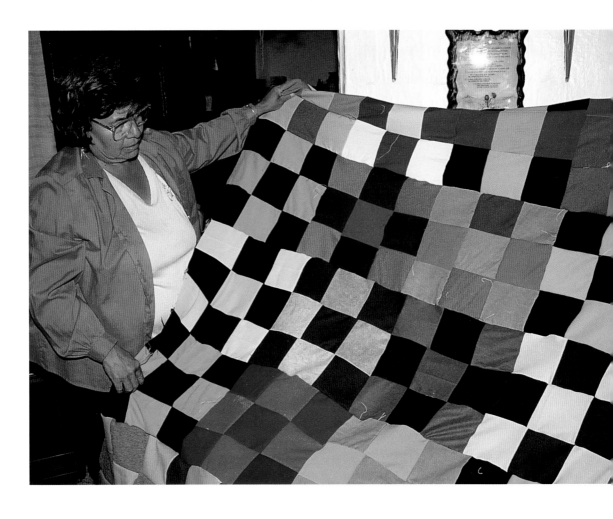

NINE PATCH
"I don't use anything but double-knits anymore;
the rest aren't worth the trouble." Viola Silva,
Arroyo Hondo, New Mexico, 1993. Photo by
Willi Wood.

Chapter 3

SOME SPECIAL PEOPLE

The survey team arrived in Tierra Amarilla the same day the new senior center building was being delivered. Every few minutes someone would run outside to see and report on the progress of the prefabricated building as it moved in. This center draws from a large area of small plazas, and the townspeople were anxious for the larger building.

Quilts were waiting when we arrived. Three hours later quilts were still coming as one person and another remembered a special quilt forgotten at home, and was taxied out to get it. There was no evidence that the ladies would ever stop making "blankets" or speaking Spanish as they laughed and struggled to translate for us.

Still talking avidly about the details of one quilt and another, we, all five of us, ate our picnic lunch in the churchyard before driving back through town to admire the new senior center. It contrasts so vividly with the old courthouse, which has bullet holes still intact from the time thirty years ago when the National Guard had been called out to keep the peace.

When I ask about ancestry, especially in the mountain villages, the answer is invariably, "Our folks have been here forever and forever." Indeed, they might be descended from those original settlers who crossed the Rio Grande at El Paso in 1598. "These freckles? My great-grandmother was Irish. They were going to California, but the wagon broke down and while her folks were working to get it repaired she met 'him' and her folks dumped all of her stuff out of the wagon and said 'goodbye.'"

What is life like for a woman born when New Mexico was still a territory and who speaks only what is today a foreign language? The number of old neighbors begins to dwindle. Even the local priest, a young man from the eastern United States, has mastered only the simplest Spanish phrases.

Elena Gonzales Aguilar Sanchez, who is still making quilts at age 86, has never traveled the twenty-five miles from her home in Questa to Taos to buy quiltmaking supplies.

PATCHWORK
Vitalita, piecing at the turn of the century, was clearly influenced by her craft of weaving. In her home, the specialty was rag rugs woven in strips to be sewn together for carpeting. Vitalita Rael, Questa, New Mexico, c. 1906, 57 x 76 inches. Photo by the author.

Instead, she used to give any friend "going to town" a quarter coin and the request to bring back a pretty remnant. Today a niece sends fabric from California.

What is life like at home all day? Elena's house is immaculate, with a freshly starched crocheted or embroidered doily on every horizontal surface. It is the cozy home of one person, with a sunny, large, and welcoming kitchen. There is a smaller sitting room and bedrooms in the rear. It is the house where she was born. It has expanded and contracted to fit the needs of the family. In the 1920s

and '30s her grandmother, Vitalita, and mother had a thriving business in the house weaving *jergas* (carpet in strips) for 25 cents a *vara* (almost a yard) from the rags townspeople brought to them. Her mother, Maquelita, also made quilts from the best scraps found in the bags for rugs.

Elena's job was to clean the house, cook, and tend the children of her brother's family, which eventually numbered twelve. No wonder she had to drop out of school in the fifth grade. "I was so tired, but I had no way out." Things did change. Her brother was finally

SUIT SAMPLES
Over 600 wool sample swatches are bound with
a plaid binding and tied with spring-green yarn,
still bright after three-quarters of a century.
Maquelita Gonzales, Questa, New Mexico,
c. 1920, 64 x 75 inches. Photo by Willi Wood.

able to build his own home. Elena married at age 28 and raised five sons. However, her mother gave the sister-in-law the old Singer treadle sewing machine, and to Elena the words, "Now you are married you must make your own quilts." Elena still has the Stradivaro electric portable bought for her by her husband fifty-seven years ago, and the giant yarn needle she uses to tie her quilts.

Like her mother, Elena makes quilts for sale as well as for every family member. Her sample blocks include diagonal strips, pinwheels, kites, and stars, but her favorite appears to be *relámpago* (lightning) with or without *entremedio* (sashing). The pattern is a one-patch parallelogram assembled by alternating dark and light patches. Her quilt size is determined by measuring her double bed. "I guess I thought the children were always going to be small." That size makes it possible to store the finished quilts between the mattress and springs while waiting to sell or use them. The backs of her quilts are one piece or pieced similar fabric, which is then brought over to the top and slip stitched down around three sides before sliding in *la pasta* (filling) of

RELÁMPAGO (LIGHTNING)

Elena made quilts for sale in the community. Just the size of a full-bed mattress, they were neatly stored, awaiting customers, between the mattress and springs of her bed. This quilt was bought, but seldom used, by her neighbor, Irene Real. It was later chosen to represent New Mexico in "Gatherings," a 1995 exhibit of the American Quilters' Society in Paducah, Kentucky. Elena Sanchez, Questa New Mexico, 1945, 53 x 74 inches. Photo by the author.

a worn blanket or spread. All is then laid on the floor for smoothing, pinning, and inserting the ties of double-crochet cotton. Bricks hold down the four corners.

In nearby Arroyo Hondo, Viola Arellano Silva was born during the Great Depression, "but we didn't really notice. We just went on living like we always had, off the land." Viola still lives in Arroyo Hondo, in a house she built herself. Her husband was permanently crippled in a mine accident the year after they were married. He never walked again. At the time of the accident in Wyoming, she was in New Mexico caring for her terminally ill mother. When the news came, Viola immediately set about doing two things: raising money to buy a dependable truck and learning to drive it. It was August when Viola brought Mr. Silva home to family-owned land in Arroyo Hondo. There were only two months remaining before the winter snows would come. With his advice, she set about building their first two rooms. To save time she laid three courses of adobe bricks and plastered them the same day. Today the house has seven rooms.

The Silvas have thirteen children. I asked her how they managed. "We fed the youngest and sent them out to play; then the elders could sit and eat and talk." She tended a four-acre vegetable garden each morning before breakfast. When asked about meat, Viola simply gestured toward the outside of the house and all the outbuildings, which are decorated with antlers: good hunters in the family.

Another source of pride are her casement windows, something she could not make. So, to earn the necessary cash, Viola cut and sold wood. "I only took the children with me twice to our woods because the second time, when I went back to the truck for a drink of water, there was none. The kids had used it to make 'adobes' in some sardine cans they'd found."

Quilts? She's made hundreds by working at night after her other chores were finished. "I have a table in my bedroom where I sit and visit with the children and cut pieces for quilts." There are ten pairs of scissors in a drawer of her Atlas Precision sewing machine so she can switch around and not tire her hand.

I was impressed by her organizational ability and by the prodigious accomplishments of this tireless woman. What had kept her going all these years? Her answer was full of faith. "We always gave away the first picking of everything; my husband insisted, and it has come back to bless us over and over." Mr. Silva died in the late 1980s. Viola's son offered to build her a new house, but no, "This one has too much sweat and tears in it."

Ida Segura Martinez is an exception to the stay-at-home rule. Born in Cerro, she came to live on her husband's land in Arroyo Hondo where, after fifty years of marriage and twelve children, "I'm still the foreigner."

Moving was in her blood. "We moved north to Sunshine every winter," Ida recalled of the 1930s, "because Cerro had no school. Sunshine had a one-room schoolhouse—sometimes [accomodating] as many as fifteen children, sometimes only seven or eight. The school was run by the Presbyterians. They taught quiltmaking too. Every week my mother made a quilt block and took it to the

SUMMER GARDEN
A book of drapery samples and a discarded white sheet got this quilt underway. Ida Martinez, Arroyo Hondo, New Mexico, 1998, 77 x 84 inches. Photo by the autor.

home of the hostess for the week; it was going to be her quilt. As much work as possible was completed that day and the hostess finished it. All I really remember was the good food and also lying on the floor and looking up under the quilt. Would you believe the sheets on my bed, some of them were made from those little tiny Duke tobacco bags all sewed neatly together? We had mighty pretty bed things in those days."

Ida went on to high school in Taos where she kept house for a local family in exchange for room and board. Attending the senior prom was one of her happiest nights—not only was she on the arm of her husband-to-be, but she was also wearing the dress her homeroom teacher had helped her to make.

As the years have passed, Ida has never lost her respect for the old thrifty ways. Her home is filled with artifacts rescued from local churches being remodeled. She reupholsters old furniture, passes good clothing on, uses scrap for quilts, and the "beyond repair" is torn into strips for weaving rugs. When the old church building in Arroyo Seco was abandoned as too small, Ida raised money from suppers and quilt sales to outfit it with looms and sewing machines so the

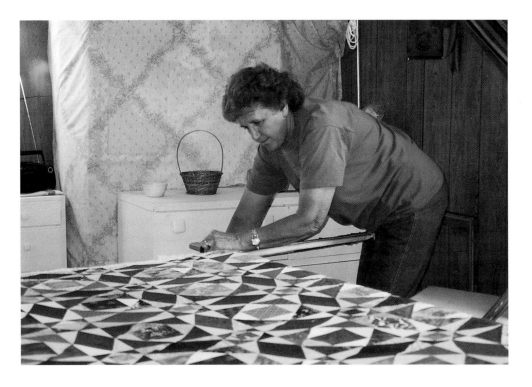

Rolling the frame. Carolyn Wells, Claunch,
New Mexico, 1997. Photo by Lorraine Ciancio.

local women would have a place to congregate. Many young women who could barely remember the craft of their grandmothers were taught by Ida to weave. Anglos, too, have come under her spell, myself included.

I first met Carolyn Dils Wells, an Anglo quilter from the southern part of the state, at the rural quilt survey in Mountainair, her hometown. Her grandparents had come there from Kansas to settle in the early part of the century. Her present home is in Claunch, where Carolyn's husband Bill takes care of road maintenance for western Socorro County. She was so relaxed, patient, and good-natured, that when I wanted more insight into a way of life in southern New Mexico, I invited myself to visit. It was spring, high school graduation time, and a community ice cream social was coming up. Finally we settled on a date. "The elevators will be on your right. Turn left to the three trailers. Yep, past the post office."

It was hot and dusty, the bare compound swept clean by the wind. Carolyn's white sneakers were spotless, her jeans pressed, the purple sweatshirt embellished with a quilt block and her smile bigger than ever. We went right to the smallest trailer, her studio.

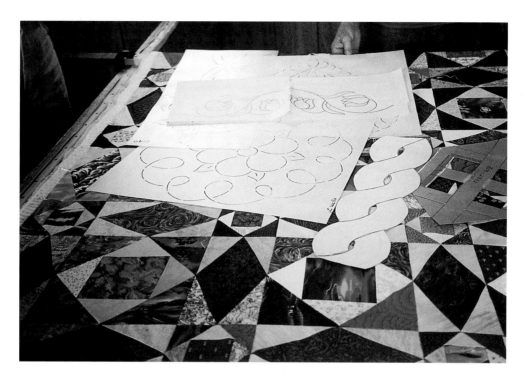

A few of Carolyn's quilting templates. Carolyn Wells, Claunch, New Mexico, 1997. Photo by Lorraine Ciancio.

Her mother had lived in the mid-sized building and the double-wide is home for Carolyn and Bill.

Carolyn Wells has inherited the boards of her mother's frame, familiar from childhood. The smallest set is 111 by 122 inches and there are two sets of longer boards for king-size quilts. "This is that lawn chair webbing that I just staple on the boards and pin the quilt backing into place. I work from both sides because it gets too big rolling it just from one side. My three chairs have rollers on them and nice thick cushions; that helps too." The trailer room is narrow enough that Carolyn can make a taut roll by pushing the frame boards right against the wall. "I like the swinging movement. When I'm doing it, it doesn't bother. The grandkids are the ones who love to swing it but they've learned that quilts are a no-no."

There was a thimble rack on the wall. "Yeah, they're all worn out so I put 'em up there. There must be forty up there. Now [the 1990s] they're making them a little stronger; making them a little more stout, like this brass one of my mother's that is still in good shape."

Carolyn's needles are quilting size eight or

nine. The other sizes seem to bend or are too big. "The regular thread with beeswax works fine but I prefer the quilting thread. I have a stash because out here in Claunch you don't just run to the store. Sometimes I do eight hours a day [Carolyn also quilts for other people] when I can take an hour or two for lunch."

"I spend a lot of time out here in the studio. There's a TV and a radio and tapes and record player. People tell me it makes a little click when I quilt, but I don't know why. When I come to the end of a thread [she starts with about four feet] I do a little backstitch and then another backstitch a little farther along. I pull my knot through from the top to start."

Carolyn's world is not small. The grandchildren, especially, keep her in touch with the rest of the United States. One granddaughter had just taken a job in Boston. I asked, "Will you be going to visit?" "Oh, no. My Bill, he don't like to travel and she'll be home to visit one of these days." She'll find a welcoming, comforting home, a place that can absorb, forgive, and renew.

CIRCLES
Pieced by her mother and quilted by Besse. "The polyester knit fabric was firmer for Mama's stiff fingers." Besse Lee Watts, Willard, New Mexico, 1973, 56 x 76 inches. Photo by the author.

Fabric and Materials

In the spirit of adventure, it is the team's standing rule never to eat in the same place twice. This led to making a U-turn in Estancia because there were so many cars parked under a Bar-B-Q sign. Not only was the food good, but at the next table there were three customers and ten legs. The four table legs were wearing blue jeans and cowboy boots.

The following day we were in Moriarty, a town on Interstate 40 with many eating franchises. Fortunately, we were too tired to drive, and settled for an all-but-hidden restaurant near the senior center. They had the best pecan cream pie I've ever eaten.

Not surprisingly, our rule has been broken, but only once. The old downtown section of Las Vegas is extremely quiet. That is what makes it so easy to find the Spic and Span Restaurant. They serve breakfast and lunch. The pastries are hand-high and the breakfast steaks fall over the sides of the plates. In cattle country like this it is not unusual to see steak on the menu three times

a day. Our selections must have been much more modest, but I don't remember because locking the keys in the car erased the gustatory memory.

By definition, a quilt is "two or more layers of something fastened together somehow." What are the sources of materials that are used?

Over the years isolation has been a problem. The 1980 federal census figures show a rural population of barely three people per square mile in New Mexico. "It would have been a 36-mile round trip if Dad had forgotten and brought home the wrong flour sack pattern," recalled Kay Croskett Connors of Silver City.

A utility quilt can tell us what the family was wearing the previous decade. Only the good parts were used for tops; worn pieces became batting. "My grandmother was the midwife in Chupadero," said Erlinda Gonzales, now living in Las Vegas, "and many times she was paid for her services in fabric,

FLOUR SACKS
*"The kids took the strings out of the tops of the
flour saquitos (sacks) and added them to the ball.
Then the saquitos were smoothed and folded
until it was time to make a quilt." Loyola
Lucero, Mora, New Mexico, 1945, 60 x 80
inches. Photo by the author.*

old suits, et cetera, that I had to help her cut up to make quilts."

After her children were all in school, Ida Martinez started to teach for the Home Education Livelihood Program (HELP) in Arroyo Hondo. "I taught adults all kinds of crafts, mostly quiltmaking and sewing. I got going on quilts like crazy. When the class left, I'd just continue with the scraps they had thrown in the wastebasket. I had three wastebasket quilts. The ladies were very extravagant. I'm not an extravagant person.

To me an inch square of fabric is precious. 'You must have grown up poor,' my son said. I said, 'I don't deny it.'"

During the Great Depression of the 1930s the stories become desperate. "We were living on a homestead near Quemado," remembers Neva Turner. "I had nothing to work with, but my husband and two brothers smoked so I accumulated enough tobacco sacks, ripped them and washed them and dyed half of them red [10-cent package of dye] and then made up my own pattern."

TOBACCO SACK QUILT
"It was 1935. There was no money. There was no material. So I saved the tobacco bags and made up this quilt." Neva Turner, Quemado, New Mexico, 1935, 72 x 80 inches. Photo by Willi Wood.

From Moriarty came the words of Lorine Cravens, "Scraps of old clothes, scraps from dresses—we were so poor we could only use scraps. When we had enough scraps, we'd just make a quilt."

As a child, Sofia Olguin remembers the adventure. "Grandma and I went on horseback to T. B. Burns Store and Bank in Tierra Amarilla to buy a little bit of this and a little bit of that for her quilts. It wasn't really a bank; Grandpa just had an account there where we could draw against his wool production for the next year."

Tobacco bags were very popular in the 1940s, perhaps because they were too small for many other purposes. So not only did the family have to wear and wear out their clothes, but every tobacco bag and its yellow drawstring had to be turned in to Mama for credit. Forty-four drawstrings were necessary to tie one full bed-sized quilt.

"During the war [World War II] my mother and her friends would get together and cry and pray and smoke and make quilts. I called it the Golden Grain [brand of tobacco] Club. She took those tobacco sacks and stuffed them and made like a biscuit quilt," recalls Nemesia Varela, a Pecos resident.

"Cotton scraps, Duke brand tobacco bags dyed with sage and chokecherries, and flour sacking—that's what she used." Loveida Cisneros was speaking of her mother in Cerro.

Pearl Spurgeon of Glenwood said, "Everyone was using Bull Durham tobacco sacks, taken apart and dyed, to make into Burro quilts [a quilt depicting a donkey], but I didn't use the sacks because my husband had stopped smoking, so I bought new fabric."

Flour sacks, plain and printed, have always been the quiltmaker's standby. "My mother had given me a few flour sacks, feed sacks, and also used, old blouses. This is what I had to make the quilt for my marriage bed." Merlinda Cordova's quilt just dances with color, because the sewing threads she used to appliqué her blocks were little bits of color from the ends of many spools. Even thread was scarce in Chamisal.

"My father's mother made quilts using printed flour sacks. She would send my grandfather out to buy the flour and tell him which pattern bag he was to get and he had to remember, or else!" said Bersabe Herrera of Las Vegas.

There were many memories from the 1960s and '70s. "Beatriz was very short so we always had a good piece of new material cut from the bottom of every new dress," recollected Loveida Cisneros speaking of her mother.

"Lura liked the polyester to piece with after she got arthritis because it was easier to use," her sister Ruby Shaw of Mountainair told us.

With the revival of quiltmaking during the National Bicentennial in 1976, specially printed quilt-top fabrics became available. The preprinted baby quilt tops have become very popular throughout the state. Sometimes called "cheater" cloth, these tops require no appliqué or embroidery and are therefore quick to make. These are another example of new material bought from chain stores like House of Fabrics and Wal-Mart.

Even in the 1990s isolation is still a reality for Carolyn Wells in Claunch, population less than fifty. "I go to Mountainair and Belen [for supplies] and to the bank and to

FOUR PATCH
*Tobacco sacks are easy to identify because the
commercial product is sewn up both sides,
making a long strip when opened. Beatriz
Quintana, Cerro, New Mexico, 1948,
73 x 62 inches. Photo by the author.*

STREETS OF KETCHIKAN

For four years Klea and her husband traveled in a motor home and wherever they stopped Klea bought another piece of red fabric, 60 in all, to make this quilt. Klea Montgomery, Socorro, New Mexico, 1988–92, 88 x 88 inches.

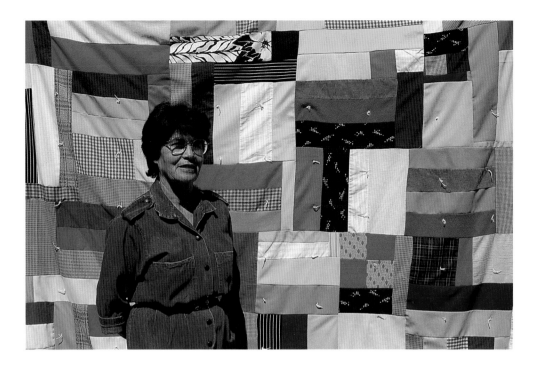

SQUARES ETC.
"I had this old red coat and some corduroy pants and that's how you begin to make a quilt. To me, quilts are the squares." Emma Atencio, Dixon, New Mexico, 1952, 70 x 76 inches. Photo by Willi Wood.

visit my daughter in Carrizozo. I get my fabric in Belen [160 miles round trip]. Sometimes my sister takes me to Albuquerque, but I don't drive up there. I have a friend in Wyoming and she sends me stuff from their quilt shop. And when I'm anywhere and I see a piece I like I buy three or four yards so I'll have enough when I want to make a quilt. Mostly in Belen I get at Wal-Mart, or I just have to wait."

However, even in the 1980s and '90s the scrap tradition still flourishes. "I save corduroy pants and I have an old jacket, and I start to cut the squares, and that's where a quilt comes from," said Emma Atencio of Dixon.

Viola Varos's quilt tops made in Arroyo Seco always had a bright sprinkling of red. She gave all the credit to her husband. He worked in a machine shop where bundles of cleaning rags were delivered. Whenever he spotted a particularly pretty print, especially if it had some red in it, he'd wipe sparingly and then fold the piece of cloth and put it in his lunch box. There was a present for Viola almost every night.

STRIPES AROUND THE WORLD
Mr. Russell attempted to inspire his employees to
use the cutting room scraps from his shirt factory.
Truman Russell, Silver City, New Mexico,
1993, 82 x 110 inches. Photo by Willi Wood.

"The family saved their men's wool suits for Gran's quilts. Occasionally there is a square [in a quilt] with a label glued on it; this was material from the sample book she'd used in a brief attempt to sell men's suits." Edith Dyer's granddaughter, Robbie Scott of Taos, went on to say that her grandfather was a well-driller who always wore coveralls to work, so when he died, his wool suits were like new. Edith promptly began to cut them up, first the large nine-inch squares, then smaller squares from the scraps to make little quilts to put on the floor under a baby.

Men's clothing was the source of scraps in yet another way. Truman Russell of Silver City said, "We manufactured men's shirts and had a lot of good-sized pieces left that were just thrown away, and I was showing our employees what they could do with the scraps. That's how I got started making quilts."

For strength, denim is popular and durable. Mary Joyce Fidel of Peñasco said, "When my two sons left for college they cleaned out their closets. I had enough old jeans to make three quilts." In Española Tessie Martinez said, "After the Desert Storm war was over I went to the boys' room and found all these jeans with holes in them and I started to cut them up."

Today there are more choices, and change is apparent, but there are still those who cherish the challenge of scraps. Aurora Garcia in Ocate said, "We were fourteen children—two boys and twelve girls. My mother was always sewing and crocheting and I just picked it up. Then we used the scraps from clothes for quilts. Now I buy most of my material from Wal-Mart."

"A lot of people sew around here and they know that I quilt and they bring me boxes of scraps," Birdie Spears of Magdalena said. "I just love getting a new box of scraps and disappearing in it up to my nose."

"This miniature quilt was made from new scraps won in an Internet raffle," admitted Betty Reynolds in Socorro.

The opposite is sometimes true. Beatrice Mactavish pieced a top in the early 1930s, a Grandmother's Flower Garden, that she never bothered to finish because it was made not from new material but from the outgrown shirts of her two sons. Her earlier, finished quilts are exquisitely made from fine new cottons and cotton sateen, specially ordered at the Magdalena Mercantile, owned by her husband and father-in-law.

Availability—access to a store—seems to have been as much of a factor as money in the acquisition of new fabric for quilt tops. Distances were long for rural people; paved roads were few in New Mexico until after World War II. The trip to town for supplies was usually only a semi-annual event for a ranching family. This isolation is reflected in an old church-published cookbook from Moriarty. Recipe after recipe calls for a tall can, a half can, and up to eight cans of this and that for a complete casserole. No running to the store for a missing ingredient. One had to use what was on hand—scraps included. And, also, thrift becomes a habit. In the 1993 words of Aurora Garcia, "Save everything. It will come in handy someday."

STAR
Made for her granddaughter's high school
graduation. Birdie Spears, Magdalena,
New Mexico, 1986, 61 x 80 inches.
Photo by the author.

Costilla, only a mile from the Colorado border, was the turn-off for our visit to Amalia, five miles to the east along Costilla Creek. There are narrow meadows along the stream with small ranches, looking idyllic in summer but undoubtedly snowbound in winter. As one of my husband's teaching colleagues phrased it, "In the old days, if you were born in Amalia, you died in Amalia."

When my husband stopped teaching in 1976 there were rumors that Amalia was going to get television. Two years later it finally came true. The mountains that had provided grazing, fuel, refuge, and food were also a geographic barrier to change.

However, it was a peaceful summer afternoon when we drove up to Carolyn Gonzales's house.

The daily thunderheads had moved off to the west and there was her one-story home with much evidence in the yard of hunting and fishing equipment to serve summer guests. Five ladies were waiting. That's about all of the permanent residents that are left since the lumber mill closed.

Driving away, we noticed the "blue bottle ranch," a real yard show. Noxema, Evening in Paris, Milk of Magnesia—hundreds of cobalt-blue glass containers are stacked, strung, and propped along every fence line of the Overson ranch. But Mrs. Overson doesn't collect just glass; a dilapidated shed near the road was covered like a Crazy quilt with old, rusty skillets—more evidence of a life where nothing was thrown away.

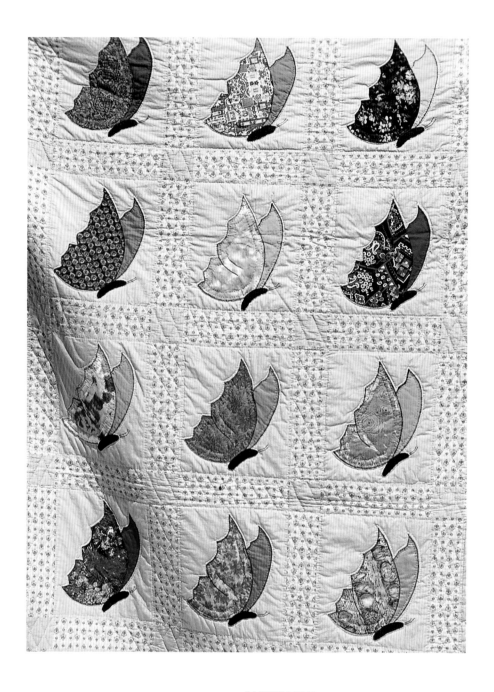

BUTTERFLY
Alta's art training is evident in both the drawing and coloring of her butterflies. Alta Cloudt, Silver City, New Mexico, 1965, 78 x 96 inches. Photo by the author.

Chapter 5

PIECES, PATCHES, AND PARTICIPATION

Española is south of Taos on the road to Santa Fe. The survey team wasn't expecting any scenic surprises so close to home. However, after one contributor had made two short trips home for more quilts, we were determined to see her village of Alcalde, population 308. The main street of Alcalde is somewhat paved. A youngster bouncing a little ball considered it his path. I pulled the car to the side while he passed. This is an old town on the Rio Grande. The land is fertile with irrigation from the river. The houses are adobe, rectangular or L-shaped. Some have a new, pitched metal roof; others retain their original thick sod coverings. Daisies waved at us from ground and sod roofs alike.

The kitchen gardens seemed to expand right into the larger fields of corn, beans, and pumpkins. Added to the long rows of chiles, we were looking at the basic ingredients of every norteño diet.

Who were the people who put the pieces of cloth together to make a patchwork top?

When did they do it? An old-way quilt, used for camping or lining the root cellar, covering the pumpkins or putting over the bed springs, was intended to be constructed quickly with the help of other family members.

One day in 1926 Estefanita Lopez invited her sisters, nieces, daughters, and grandchildren over to the ranch in El Valle to help her make a quilt. She had a couple of dark wool coats, one with a bright orange lining, which she was cutting and fitting to make the two sides necessary for the quilt; but try as she would, there just wasn't enough good wool to finish one side. With the team of family members ready and willing to sew and tie, she couldn't wait. Quickly she took the shears and headed for the barnyard. One surprised ram involuntarily donated a rectangle of fleece, which was couched down under cheesecloth to finish the quilt that day. This quilt has survived because generations of

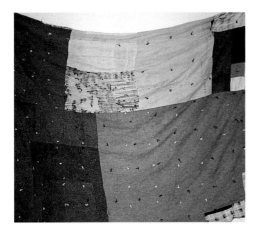

WOOLLY

"Material was scarce. The family owned a black sheep. We kids called this quilt 'Woolly.'" Reminiscences of granddaughter Mary Joyce Fidel. Estefanita Lopez, El Valle, New Mexico, c. 1926, 53 x 69 inches. Photo by Willi Wood.

WOOLLY

Reverse. Estefanita Lopez, El Valle, New Mexico, c. 1926.

children have loved to rub that wool patch and refused to let it be recovered.

New-way, fancy quilts take more time. So many memories of grandmothers begin with the words, "Any free moment she had, she pieced on her quilts."

There are also many hints of family members pitching in where appropriate. "My boys cut the cardboard patterns for me. Then I would cut my quilt pieces in the evening while they did their homework," recalled Elena Sanchez of Questa.

Although Viola Silva's husband was badly crippled, he always wound bobbins for her, thirty to forty, in preparation for a day of assembling patches in her home in Arroyo Hondo. Viola planned to take about two hours to assemble a quilt top.

Husbands contributed in more oblique ways too. Garnell Allred's husband was a musician and she did her piecing while traveling the roads of Catron County with him. Or there are the lonesome evenings when husbands are out politicking or elk hunting; that's when quilts are pieced. Husbands can also indirectly determine the method of piecing. Ernestina Aguello said, "At home I use my machine. If I have a lot of time, like when we're driving back and forth from Taos to the ranch in Ocate, I do it by hand."

One time Ida Martinez had a Cathedral Window quilt on display in the old church in Arroyo Seco when two tourists stopped in. "Look, Mud; they got one o' them glove compartment quilts." I asked what she meant. "You know. A gal would tear up her

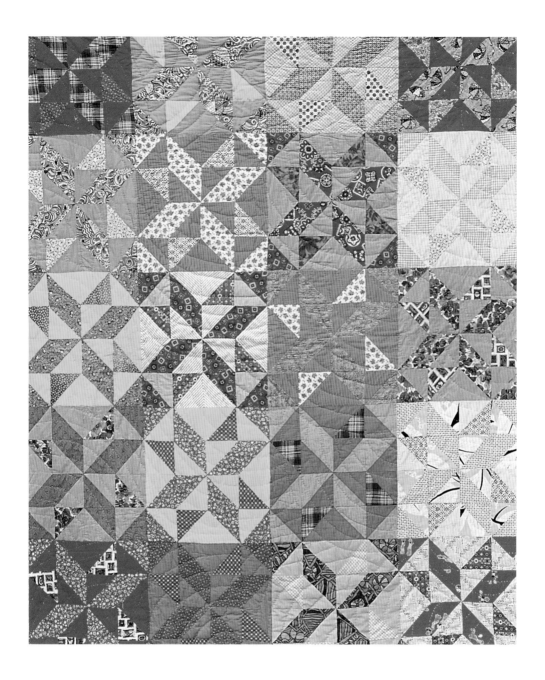

PINWHEEL STAR
*"I get the patterns from books, magazines, people,
and some I just cut out from my imagination."*
*Ernestine Arguello, Ocate, New Mexico, 1980,
51 x 72 inches. Photo by Willi Wood.*

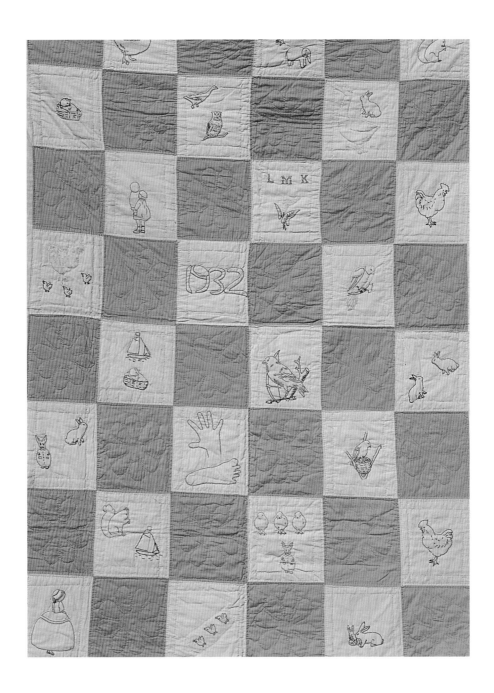

ANIMALS
Embroidered when Lena was eight years old.
Her mother did the assembling and quilting.
Lena Shellhorn, Reserve, New Mexico, 1932,
66 x 84 inches. Photo by Willi Wood.

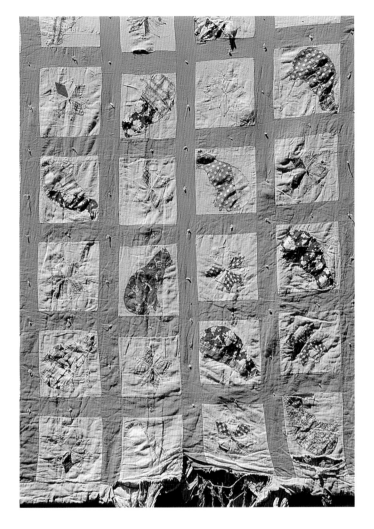

LA ESTRELLA (STAR)
"I looked at my cat a lot.
I drew him and put him in
the quilt," Pablita told her
niece, but she was most
proud of having worked
out the star pattern.
Pablita Maes, Trementina,
New Mexico, 1925,
68 x 78 inches. Photo
by the author.

muslin squares and tuck 'em in the glove compartment of the pickup. Of course, there was a thread, needle, and thimble too. Then she'd be ready any time the old man wanted a passenger. Them's too tedious to work on in the house," are the words of an unidentified visitor.

Joe and Crucita Sedillo, now more retired than before since Joe has cut back on the number of cattle he raises, work together in Quemado embroidering their printed blocks and then quilting them.

Where did children fit into the quilt assembly line?

"I did the embroidery on those blocks when I was eight years old. The hand-and-footprint block, right there in the middle, is of my youngest, meanest brother, a brat. We had to put him on the quilt because he threw a fit. It was my first and last quilt,"

recalls Lena Shellhorn of Glenwood, Catron County.

Other children had different experiences. Carolyn Wells, growing up in Mountainair, tells us that "when the weather was bad we kids—there were six of us—had to stay home from school; one would press material, one would cut out, and one baste things together [to be sewn later by Mother on her treadle sewing machine]. The other kids were at the frame quilting."

Pablita Maes, at age 15, pieced her Star quilt while she was herding sheep near Trementina. She even took along a small flatiron that she heated on the fire, then found a smooth rock and ironed the small patches of old material.

Another loner was Erna Randall. "I made those two quilts to pass the time. Mother had taken the two younger children to live in Santa Fe for the winter, so they could go to school. I stayed home to take care of my father, the house, and our store and post office at Eagle Nest. I searched the house for every bit of dress goods to make those quilts so I'd have something to keep me busy in the store." Eagle Nest is situated in a picture-perfect mountain valley 9,000 feet above sea level, where winter weather begins on Labor Day and concludes on Memorial Day.

Piecing a quilt top can fill many categories, from grim necessity to restful time alone or in company. For some, piecing was considered leisure, especially if one had gotten a bit ahead of the necessity for warmth. In 1931 Lola Linebarger and her friend Peg Hendricks spent afternoons in Servilleta piecing their blocks from the template-cut fabric all strung on a thread to keep different shapes separate. Her daughter said, "I remember one time Mother called Peg and said she had her quilt top all assembled, and this was just the morning after they had been sewing together, and Peg said it wasn't possible, and Mother said, yes, it was, because she had used her sewing machine." Shortly thereafter Peg moved with her husband to a new job in Nevada, and Lola, without her friend, ceased making fancy quilts. The sewing machine could not replace the companionship of working together.

In contrast, Angie Baca likes to work alone embroidering her quilt blocks in the morning with coffee, late in the afternoon, and on Sunday. She spends a lot of time sewing for others, sewing clothes to sell, and doing alterations for Taichert's Department Store in Las Vegas, San Miguel County, but she embroiders for herself during coffee breaks.

For some quiltmakers piecing a top is a shared pleasure; for others it is a lone activity. Sometimes it is a necessity, sometimes it is therapy; always it is product oriented.

Every piece of patchwork or appliqué does, however, reflect the ideas of the maker. Alta Cloudt had had formal art training which she used, after marriage, in her quilt designs. Her original appliqué pattern of a side-view butterfly appears in several quilts made by Alta and her relatives in the Cloverdale-Silver City area in the 1960s.

In Canjilon, Dolores Baca said that for her wedding quilt made in 1954, she and her sister traced the appliqué flower motif from their mother's rug.

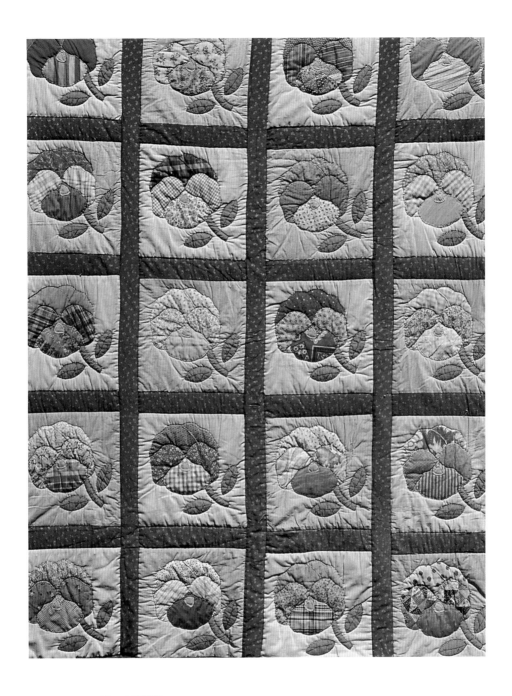

MARRIAGE QUILT
Angie made this quilt for her son's wedding.
Angie Baca, Las Vegas, New Mexico, 1980,
60 x 74 inches. Photo by the author.

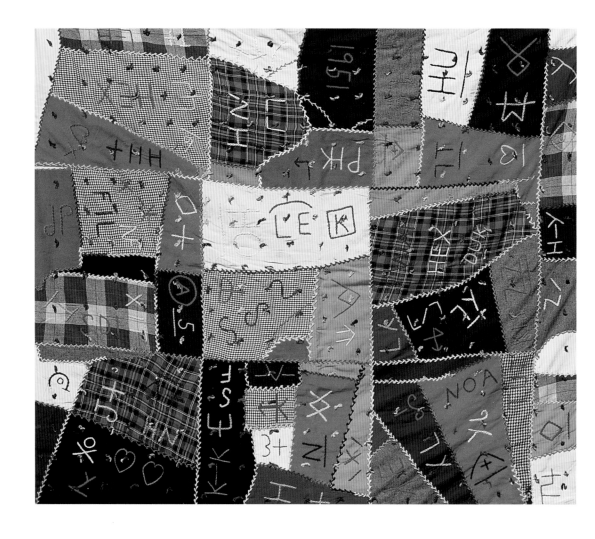

CRAZY WITH BRANDS
This was her last brand quilt. Perfecta used the
final scraps to make a robe for her daughter
Lena that same Christmas. Perfecta Kiehne,
Reserve, New Mexico, 1951, 62 x 74 inches.
Photo by Willi Wood.

In Wagon Mound in the fifties and sixties, Elvera Archuleta was busy making quilts for her nieces and nephews. "I would cut squares from the plain white feed sacks, tie a knot to make the square into a tent, then tie it in the middle three times, wet in dye, and dry. The squares came out looking like a flower. I pieced them together."

As a child in the thirties, Erlinda Gonzales in Chupadero cut the pictures of flowers and vegetables from the cloth seed sacks to make pretty quilt squares.

From Costilla in Taos County came the words, "Who taught me? Myself. We were five brothers and four sisters and no mother, so who was going to teach me? I did it myself." Lucy Trujillo's patterns are unique. One is an appliqué of horses' heads, a gift for her husband.

In Catron County, Lena Shellhorn told us, "My family [Kiehne] and Junior's family [Shellhorn] have been in the ranching business for over one hundred years, which is why my mother, Perfecta Romero Kiehne, knew all the cattle brands and their owners. She made this brand quilt for Junior for Christmas 1951 and he said it was the prettiest present he got."

Viola Silva from Arroyo Hondo uses templates in two sizes, a child's three-inch square and an adult's six-inch square. The templates are fashioned potholder style out of several layers of cloth stitched together. Thus Viola can cut patches in the evening without marking or good lighting because her scissors can't penetrate the thick template. She feels the shape. When the cut patches begin to overflow the storage box, it's time to make a quilt. Color combinations she likes form the checkerboard patterns for the top and back of the quilt, and unpleasing leftovers become a sheet of fill.

There are more sources. For Adela Tapia of Las Vegas the ideas come from the amounts of fabric. Her Trip around the World has many detours, as one color runs out and another takes its place.

From Questa came the words, "Maria Ortega got this pattern from my mother. They're neighbors. People passed patterns around a lot. They never looked quite alike."

Angie Baca of Las Vegas began embroidering blocks for her children's quilts long ago using her son's kindergarten coloring sheets. Now, when she sees a "fun" picture in a coloring book, she buys the book, tears out the pictures she wants to embroider and gives the rest of the book to a grandchild. A hundred miles away in Cerro Sadie Aguilar also uses her daughter's kindergarten coloring sheets to make butterfly and animal appliqués.

Jill Cooper of Mountainair told us, "In the fifties my grandmother lived near Cedarvale on a ranch with a huge windmill, the rancher's right hand, just outside the front window. Southwest Windmill became a favorite quilt pattern for Grandma and me."

Another source of inspiration is color. "It was a real big deal if you got a piece of wool that had a bright color to it," remembers Loyce Wood Sage.

From Birdie Spears, "I love matching colors. That's the best part of quiltmaking."

"The home extension taught this pattern, Cathedral Window, in the 1980 bulletin.

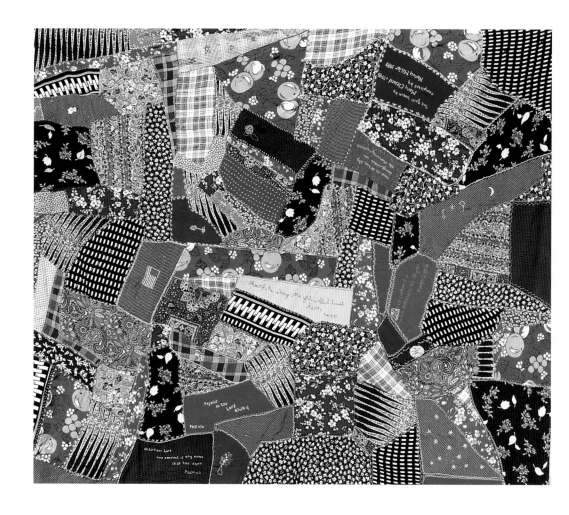

CRAZY
The quilt pieces are hand and machine sewn to
an old sheet made of feed sacks. Pieced for her
son, it was finished forty years later by his wife.
Mary Cleland and Nancy Miller, Mimbres and
Bayard, New Mexico, 1949–89, 70 x 86 inches.
Photo by Willi Wood.

I just chose my favorite colors, pink and turquoise," said Natividad Lucero of Amalia.

"My daughter-in-law puts those bright chicken feet (feather stitch) on my tops for me. Makes it look so pretty," Eduvigen Martinez of Los Ojos told us.

Another inspiration is in the technique employed by the quiltmaker. The old-way approach has found new life in the contemporary wall quilts made for purely visual delight. It may seem strange to think of any old-way quilt as a work of art, when durability and warmth were the uppermost considerations, but the very speed of construction brings a devil-may-care attitude to the organization of the scraps. Necessity provides startling color combinations. Compositions are unbalanced. Many quiltmakers enjoy the freedom from constraint and the opportunity to experiment. There is spontaneity and joy in these quilts that can leave a traditionalist gasping. These methods have become the precursors of the art quilt: the unorthodox, experimental approach to assembling fabrics.

These are just a few of the surprising techniques used throughout the state to individualize a quilt and make it something special.

FOUR PATCH
"We used those sacks for everything back then."
The filling is feed sacks; the backing is salt sacks
dyed yellow. Alice Archuleta, Wagon Mound,
New Mexico, c. 1960, 70 x 74 inches.
Photo by the author.

Chapter 6

BACKING AND BATTING

Our survey target this day, Chama, is the western terminus of the Cumbres & Toltec Scenic Railway. Great billows of smoke were rising in the cold morning air of September and whistles were blowing to attract passengers as the rural quilt survey team drove into town. We quickly turned away from the bustle of the main street and found the senior center. Spanish is the language of choice there and the young van driver was extraordinary in his ability to carry in heavy quilts while translating "on the run."

Driving north and west from Taos that morning with the Chama River on one side and the Brazos Mountains on the other, the signs to fishing and hunting camps had been the only interruptions for many miles along the highway. We determined to have lunch in town, where a local cafe advertised fresh trout. It was delicious.

The backings on New Mexico quilts are almost as varied as the tops: more of the same patchwork, larger patches of scraps, flour, sugar, and salt bags, purchased cotton flannel and prints or solids in yardage or sheet form.

"One thing we used to do in the sixties was machine-sew patchwork pieces directly to a blanket, which became both the filling and the backing," recalled Mora County quiltmaker Aurora Garcia. Salt bags, white with a red pinstripe, provided a backing in the 1960s for Alice Archuleta, another Mora County resident.

Jesusita Valerio, working in Ranchos de Taos in the thirties, used the Colorado Portland Cement Company "Ideal" bags for the back of one of her sheep-camp quilts. Josepha Gonzales had print flour sacks for both the front and back of the quilt she made for her wedding in Chamisal, Taos County, in 1923.

Dates don't seem to matter. It is the style of the quilt that determines the backing. In 1995, when Gregorita Aguilar of Los Ojos was making an old-way quilt, she finished the

DOUBLE-KNIT
When Gregorita starts, she just keeps piecing
until both front and back of the quilt are there
to be folded, stuffed, and tied. Gregorita Aguilar,
Los Ojos, New Mexico, 1995, 84 x 124 inches.
Photo by Willi Wood.

top measurement and then kept right on going to complete the similar piecing for the back. In 1938, when Eva Martinez of Ranchos de Taos was making an all-wool, all-new-material quilt top from 143 men's suit samples, she bought a bolt of a red cotton print to back the quilt; she also made herself a dress and more things she can't remember. Edith Dyer of Taos always put a red flannel backing on her men's-suit-scrap quilts made in the seventies and eighties. She tied them with red yarn "so they'd be pretty."

The newer the quilt, the more likely it is to have a whole-cloth backing. Once, living along the railroad brought goods practically to one's doorstep. Today that convenience has extended to anyone with access to an automobile. Hitching up a horse and wagon and devoting an entire day or more to a trip to town was another story. The need and desire to use what was at hand saved both time and money. "These colors aren't just right, but, you know, if you got it cut, you had to sew it up."

A thrifty housewife, the home economist bulletins tell us, was much to be admired. The United States Department of Agriculture in 1921 described farm women as those who "delighted in finding ways and means by which to make her surroundings yield up to her and her family the best things of life."

There were ways to circumvent problems and equalize distances. "My mother, Irene Gonzales Rael of Questa, spoke hardly any English at all, but she knew how to use the telephone [1940s] and call Montgomery Ward in Taos and order her cloth at 29 cents per yard and figure up the price and everything just right," remembers Lila Rodriquez.

Lola Linebarger was also a Taos Montgomery Ward customer, ordering packages of new cotton scraps for 30 cents a bundle in the early 1930s.

Mail order was especially popular before World War II, when many roads in New Mexico were unpaved. Not until the presidency of Dwight D. Eisenhower was an effort made to create a federal highway system that would permit the delivery of mail by truck rather than railroad. An envelope of iron-on transfer embroidery patterns could be ordered from The Pictorial Review Company in New York City for 15, 19, or 20 cents. The national newspaper *Grit* had a weekly pattern column. This is where Tillie Velasquez of Costilla, in the 1950s, ordered transfer patterns for all (then) forty-eight state flowers. She completed the quilt in 1984.

Ingenuity also extended to filling a quilt, or not filling a quilt. Of our total survey of 848 quilts, 114 had no filling. Why? The quiltmaker had run out of materials or time, the quilt was heavy enough already, or, in some instances of tied quilts, the filling had been removed for laundering, and, not immediately needing the quilt, the "pillowcase" was still empty.

In the southern counties where the survey found the largest number of quilts made in the 1990s, we also found the most polyester and cotton battings in use. What the magazines are recommending and the stores are featuring has become the fill of choice.

It wasn't always so. Just once, in the 1970s, Viola Silva, a Taos County quilter, bought a Mountain Mist batt, but "It cost so much money and then what was I to do with all those leftover squares that didn't match anything?" They became her filling.

Another independent woman is a Rio Arriba County quiltmaker, Inez Leyba of Canjilon, who said in 1996, "Mostly I make quilts my way. I use older quilts for filling; keep covering them when they wear out. For the new quilt to give away or sell, I buy new blankets to go inside."

Blankets (which often mean cotton-flannel-sheet blankets) are commonly used for filling, especially for quilts that are going to be tied. In San Miguel County, Alta Biesman said to us, "All my quilts have blanket linings except the one with Henry's winter underwear in it. Now I'm getting ready to use old sweat socks for my next lining. I cut the foot off, throw it away, and sew the top pieces together to make a big square."

From Mora County, "Old sheets, old blankets. No, I don't buy batting. It's kind of expensive, you know." Loyola Lucero also used denim pant legs basted together.

Ingenuity abounds in Taos County, too. "Mom [Beatriz Quintana of Cerro] used a

DOUBLE WEDDING RING
Made from scraps of dresses, pants, aprons,
shirts, and flour sacks. The filling has been
removed so the patterns of the backing pieces are
visible. Loveida Cisneros, Cerro, New Mexico,
c. 1940, 62 x 80 inches. Photo by the author.

SQUARES
The weight-me-down quilt is filled with
gunnysacks. Dolores Martinez, Chama,
New Mexico, 1994, 57 x 78 inches.
Photo by Willi Wood.

mattress ticking to fill this potato blanket," which was made in about 1950. Carolyn Gonzales of Amalia revealed, "I put an old bedspread inside." The forty years that divide these two quiltmakers are scarcely noticeable.

One day in 1996, when the survey team was working in Chama, Rio Arriba County, in a bustle of efficiency, I grabbed a quilt to be photographed and sat right back down again because it was so heavy. The quilt looked innocent; it had to be the filling. Living near the Colorado border, practically in the potato fields, this quilter, Dolores Martinez, uses potato gunnysacks to fill all her quilts.

Apparently gunnysacks were not an unusual filling; they were just not the first choice. Later, in Dixon, Angie Atencio told me, "My first quilt [made in the 1950s] was filled with gunnysacks. I had these flour sacks and I cut squares and then I didn't have anything to put inside, so my husband said to use those old gunnysacks, so we washed them up and it was a warm quilt. It's long gone now."

Heavy quilts were not unusual either. "Those string quilts were really heavy because they had two fillings: the squares of old sheet the strings are sewed to and the regular blanket inside." Jan Combs was talking about keeping warm in her wood-heated house in Socorro, where sometimes "it is cold" (winter temperatures regularly dip below zero). Her utility quilts are made for warmth and durability by string-piecing with dental floss onto rip stop nylon to add an extra strong layer.

Surveying in Española, Bonnie Villareal from Alcalde brought in her husband's favorite quilt, the one that "won't let him move." "In the 1920s Jim's mother drove their buckboard to nearby San Juan Pueblo to trade, and since her family, the Villareals, weren't weavers, she bought her rugs there. Years later, when she gave me this quilt, it was covered in badly worn blue pieces and tied with ordinary white string. I took off that blue cover, saw the old Indian rug inside, and figured I should do the same. Yep, I bought a thin rug, sewed it to some heavy flannel, stuffed the blanket back inside and tied it all together with more string."

The transition from weaving to quiltmaking was gradual. Before World War I, Mercedes Valdez of Taos County had begun to alter her bedcovers. Her hand-woven serapes are still to be found inside some of her family quilts, under two or three outer layers of covering.

In the 1940s, in Questa, the extended Rael family would get together at night to card and spin while the elders told stories. And then at about ten o'clock would be *la merienda*, a snack supper, with baked apples. Gradually, as emphasis changed from woven blankets to pieced quilts, some of the carded wool was set aside to make *la pasta*, a filling in a rough, gray cloth casing, to go inside the quilts.

Wherever there were sheep, there was batting. Mae Willden said, "In the 1930s I made quilts for the sheep camps around Socorro from old jeans and shirts and hand-carded wool from our sheep for batting."

When Celia Martinez was a child in Mora in the 1920s, her parents and grandparents both said, "Wherever you go, find fleece along the fence. Pick it up. Save enough to make a pillow or a mattress." That fence fleece was washed before carding in a wash-

SUGAN
No longer needed by a shepherd, it was found
covering the springs of a rollaway bed. Veroniz
Martinez, Arroyo Hondo, New Mexico,
c. 1930, 60 x 72 inches. Photo by the author.

tub with a scrubboard. The water was drawn from the well. Mostly it was cold water, but sometimes it was put in the tubs and left in the sun to warm.

In the town of Mora we met in the public library, a large room in a building adjacent to the county courthouse. On one wall hung a quilt dated 1976, the year the fourth grade in Mora Public School numbered thirty-two students—the exact number, then, of counties in New Mexico. The teacher, Celia Martinez, bought pale-colored fabrics, bright embroidery floss, and needles. With the help of an opaque projector, she started each child, boys and girls alike, to embroider the name, county seat, and principal product of the county onto his material. No one shirked; no one complained. Today the quilt draws those children, many now parents, into the library.

The quilts were made to be taken apart before washing. In the 1940s, "We sewed the three sides together, turned it to the right side and then called the kids to help stuff it

67

LOG CABIN
*The breather strip is made from a 100-pound
Farmers Best flour sack. Maker and date
unknown, Estancia, New Mexico, 72 x 72
inches. Photo by the author.*

with an old blanket or older quilt." Loyola Lucero went on to say, "Quilt washing was a family affair. The kids started hauling water from the *acequia* (irrigation ditch), the night before. They went to school the next day, then came home to help with the washing. We took them apart, you know, so it would be easier."

Niza Hernandez told how, as a child, she dreaded the last day of school in Mora County because she knew that the next day would be quilt-washing day. Her grandmother made them all—aunt, mother, granddaughter—wash the "blankets." First there was the water to haul to the washtubs, then the *amole* (yucca roots that lather in water) to be crushed, and finally, scrubbing the quilts on the washboard. After rinsing, everybody got on one or the other end and twisted to wring out the water. The quilts would take two or three days draped over the fences to dry.

The Cisneros family in Cerro still keeps an old wringer fastened to a chair back to get the water out of the quilts.

In Lumberton before World War II, when the cowboys and shepherds used five or six quilts, called *sugans*, to make up their bedrolls, Vincenta Lucero said that she aired those quilts for sure once a year, but that sometimes it was only every second year that they got washed.

One way to postpone the laundering task was to baste a soil protector across the top edge of a household quilt. This is a muslin or feed-sack strip about twelve inches wide, folded and tacked in place over the top or fingering edge of the quilt.

Berlinda Ortega Trujillo remembered, "I had an aunt [in La Lama] who was so neat and clean she washed a quilt every week. Entertainment in her house was the radio, and we kids, the cousins, would get a music station and start to dance, and that aunt would hear us having fun and she would call us to come help tie a quilt. I hated those quilts. But quilts were everywhere. The women were always making quilts. My dad had sheep-shearing crews who went all over up to Montana and Wyoming, thirty men in a crew. They traveled by bus and every man had his tarp and bedroll of quilts."

Thus quilts were an integral part of life requiring ingenuity, muscle, and family cooperation. Today machines have replaced some muscle, but the favorite quilts are still those that reflect some aspect of the family's life.

UTILITY QUILT
Grace was 92 when she made this traditional
old-way quilt with a sheet-blanket for filling
and machine stitching edge to edge in place of
ties. Grace Lucero, Ocate, New Mexico, 1985,
54 x 77 inches. Photo by Kerry Heubeck.

Chapter 7

QUILTING AND TYING

Mountainair is a railroad town. With curves and hillsides intervening, the freight trains seem to have no beginning and no end. Once those cars hauled pinto beans, corn, and wool; now it is other freight. Through all of the years, however, there have been women piecing quilts and quilting at home, in the church, and now in the senior center. Five mornings a week they come to the center, sometimes only two women, often as many as eight, to sit around the frame and quilt. In fact, when times are extra busy there are two frames in operation. The quilting is done free-of-charge for the townspeople, for each other, and for giveaways, just in case there is someone in need. The binding is done by a volunteer at home—usually a back-to-front process.

"It's not a quilt until it is quilted," is an oft-repeated phrase. A set of frames for quilting, although often constructed on the spot, was a familiar household appliance for settlers coming to New Mexico from the east-

ern United States. But what about the settlers who had come up the Rio Grande from Mexico without the benefit of this tradition? Without a specific formula for making a quilt, without a great deal of time to expend, and probably mindful of the need to wash and dry these items, the early Hispanic population tied their quilts. If there was no extractable filling, two or three passes from selvage to selvage on the sewing machine sufficed. Easterners knew about tied quilts (sometimes technically called comforters) and gradually introduced hand-quilting to the local population, but both cultures have retained a strong distinction between the appropriate uses for each technique. Simply put, used inside the house: quilted; used outside the house: tied, but with many exceptions even to this simple rule.

Lola Linebarger, who came to New Mexico from Texas, had a set of four boards for

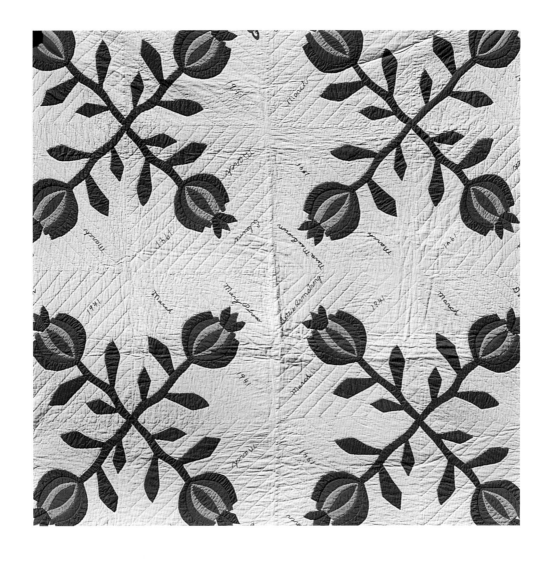

FRIENDSHIP PINEAPPLE
*Appliquéd and embroidered by mother and one
sister for another sister who was leaving. Quilted
by the entire family. Ladd Family, Claunch,
New Mexico, 1941, 66 x 81 inches. Photo by
the author.*

her frame that hung from the living room ceiling in her home in Servilleta, Taos County, around 1930. After her friend Peg moved away, Lola didn't quilt anymore. She used the frame only for tying the family necessity quilts made from wool pants and other heavy material. These ceiling frames consist of four boards, one-by-two's about eight feet long. Two of the boards have a hole at either end, and a long string or rope attaches through them to four hooks in the ceiling. Edna Holmes, Lola's daughter, has a set of four hooks in her living-room ceiling and another set in the roof of her covered patio in Taos. The two cross boards are laid across the hanging pair, adjusted for the size of the current quilt, and held in place with C-clamps. Some older frames have holes drilled at regular intervals in all four boards, so that wooden pegs or nails can be dropped through the holes to hold the boards in place. However, pegs mean the quilt backing must be tacked or bound with loops of string into the frame. With clamps the boards can be covered with sturdy cloth and the quilt backing basted or pinned in place. Either method requires no basting of the quilt layers. The height of the frame is easily adjusted by a turn of each rope around the ends of the boards, or many turns to take the frame to the ceiling when the space is needed for another activity. One simply rolls under the completed quilting at convenient intervals to reach the center of the quilt.

"If you missed the school bus you had to stay home and quilt. I guess I liked it enough to keep quilting. I've still got that old-time rack from Mom that has been used a lot. It hangs by strings from the ceiling, swings a bit, but works real well," recalled Carolyn Wells of Socorro County.

"There was always a ceiling frame hung in the house when I was growing up in Socorro County in the 1930s and everybody used to help quilt, the boys too," a former Claunch resident, Elaine Ladd Ingram, remembered.

A vendor at the Taos flea market was talking about his quilting days. "I was 8, 9, 10 years old. It would be a winter afternoon when she set herself down to quilt, when most of the family had gone to town, and in no time she'd be calling to me. 'It's cold in here, boy. That stove needs wood.' My grandma had one of those frames that come down from the ceiling and she'd do beautiful quilts, but I didn't exactly enjoy it myself. Sitting quiet like that she'd feel the cold, so I was expected to keep the old wood stove red-hot. Why, I bet I did almost as many strokes with the ax as she did with the needle. Only difference was, she got to sit down."

Quilting, once always by hand, now often by machine, is the best way to keep carded cotton or wool batting in place. Sometimes quilters work for pay, sometimes for pleasure and sociability. For instance, "My grandmother paid $50 to have this patchwork quilted and I inherited it." Dale Spurgeon of Buckhorn, Catron County, referred to a still-bright Friendship quilt from the ladies of Glenwood and Reserve, dated 1915, 1923, and 1926. In 1989 the price had gone up to $75, when Neva Turner of Quemado quilted for Isobel Griffin of Las Vegas.

Mrs. Elkins, a Native American woman whose husband worked for the railroad in

FRIENDSHIP QUILT
Pieced by friends in Glenwood and Reserve as a gift for Ida Balky, whose sister later paid $50 to have it quilted. Ladies from Glenwood and Reserve, New Mexico, 1915–86, 68 x 85 inches. Photo by Willi Wood.

Deming in the 1950s, quilted for many people. She had a quilting frame hung from the ceiling in her home and preferred to quilt in the shell (fan) pattern. With a pencil tied to a string, or even with a sharp needle on the end of a thread, it is easy to mark the quarter circles as the quilter goes along. "Everyone quilted in shells back then in the 1970s," recalls Lonis Armstrong of Datil, in the western part of the state. Farther east, in Torrance County, the preference was for the Prince's Feather. The prince was the Prince of Wales, whose coat-of-arms includes beautifully curved plumes. These were translated into quilting patterns before quiltmaking crossed the Atlantic Ocean. They have remained popular ever since because of the adaptability of the one-template design to a variety of spaces, especially the large areas around a Lone Star.

Freestanding quilting frames could be purchased from Sears or Wards or built at home. However, these took up valuable floor space and hence were not popular in the rural areas where the frames were never put away.

A group of quilts from the Kite family of Taos bears silent testimony to family involvement using a ceiling frame. There are three well-worn one-patch quilts, quilted in the fan pattern. Because of the way the fan lines are laid onto a quilt, with a pencil and string, the quilter must start from one side and continue to the opposite side. When one uses a freestanding frame it is customary to start in the middle of the quilt and work to either edge, which is not a fan-pattern option. Not only does it appear that Mrs. Kite had a ceiling frame, but also that she had help,

because the fans begin from both sides of the quilts and meet in the middle.

In Grant County, Lenora Rice said, "I started quilting thirty years ago and still haven't got my fill. I went as a young [17-year-old] bride to Relief Society [Latter Day Saints Church] and quilted so slowly I never got to do as much as I wanted, so I decided I had to make my own quilts. I still do a lot of quilting for other people and with 'em, too."

Maggie Ortiz goes from Edgewood, Torrance County, to the senior center on Fourth Street in Albuquerque to quilt, because there is always a group of people around and at least one person who is willing to help her with her quilting. "Most people who quilt seem to be in my age group, senior citizens. I do have a friend whose daughter is interested."

A ranch wife, Bernadyne Brown, recollecting from the 1950s in Catron County said, "A neighbor lady made the butterflies and I appliquéd them on the fabric, and myself and some ladies from Quemado got together at my ranch twenty miles out of town and quilted with me. All of the ladies but me are dead now."

Now, since the 1990s, it appears that the quilting bee has not vanished—just changed venues from private homes to senior centers.

Perhaps we will someday have a generation who must learn to quilt from a book rather than at their mothers' knees, but once upon a time, 1930, Leva Kempton of Socorro played under her grandmother's frame, and it was a proud moment when she was allowed to put in a few stitches. For Rufina Roybal of San Miguel County, growing up in the 1940s, it was a bit different. "When

WHIRLWIND
Jewel Kite's family all worked at the frame
to make this gingham-backed summer quilt.
Kite Family, Eagle Nest, New Mexico,
c. 1935, 64 x 84 inches. Photo by the author.

DAHLIA
One of the many tops that Lenora has quilted
"just to get her fill." Carrie Coffelt and Lenora
Rice, Gila, New Mexico, 1979, 76 x 92 inches.
Photo by Willi Wood.

Mother was teaching me to quilt, if a stitch was too long, she would pull my ear and make me take the stitch out and re-do it. I learned in a hurry."

In the 1950s in Catron County, Clara Hogsett recalls, "My 'Trip around the World' quilt started out to be a doll-cradle quilt and it just kept going. It was a teaching quilt for my three daughters. If you look closely you can find some beginner's stitches. The youngest girl was only five."

"Mother never did say she liked me to quilt," recalled Carolyn Wells. "She was so accurate. She would draw around the pattern and cut it so straight and precise. She did everything neat. When I first started piecing, she would take it out if I didn't do it right. She said if anything was worth doing it was worth doing well. 'Be accurate and do it nice,' were her words."

Thelma Rodgers of Estancia was "full grown and a little bit" (55 years old) when her stepmother gave all of her patchwork pieces and blocks to Thelma to finish. Her husband James built an adjustable, freestanding quilting frame. Not knowing how to use it, Thelma took quilt and frame down to the extension service where Thelma Vishaway was giving quiltmaking lessons. To have a big enough area to lay out their blocks, the group was using the Estancia County courtroom floor, where it was a simple task to pick up the pieces at the end of the day. However, an entire quilt in a full-width frame was another story. Court might convene that week, so the frame couldn't stay. They carefully carried it out to James's pickup and drove home, ever so slowly. Since then, with

advice over the telephone and an occasional visit from Granny, Thelma has finished ten of the pieced quilt tops.

Tying a quilt has its own requirements.

"The string we used for ties came from the Sanchez Store packages [in Mora in the 1940s] and from the tops of the flour *saquitos* (sacks), all wound into a ball until it was time to tie a quilt," recalled Loyola Lucero. In 1996 in Chama, Rio Arriba County, the seniors still tied their quilts with the white string from the sugar bags. The string from the chain-stitch closing across the top of a sugar bag had other uses too. One woman said that, as a youngster, she learned to crochet with that string, chaining and pulling out time after time until the string was so filthy her mother would wash it and then show her a new stitch.

Occasionally there is an older quilt tied with bright yellow string, proof of a smoker in the family, since yellow was the color of the drawstring in a bag of tobacco. Ties always seem to be a leftover, whether from bags or embroidering, crocheting, knitting or weaving.

Finishing the edges on a quilt might seem like a simple task of applying a binding after the quilting is completed. However, a tied quilt that grew like Topsie in the first place doesn't need to settle for the "normal" progression of events.

When Viola Silva gets ready to assemble a quilt, she sews the bottom edges, right sides together, on the machine, turns it, and spreads it on the bed for tying. With the sewn edge closest to her, she begins to smooth and stretch the layers into position.

TRIP AROUND THE WORLD
It started out to be a doll blanket for teaching
her girls. Clara Hogsett and daughters,
Quemado, New Mexico, 1950, 58 x 74 inches.
Photo by Willi Wood.

TOMAHAWK

When Velma Godown turned 91 she decided she couldn't do any more quilts and so gave bundles of cut shapes to her stepdaughter Thelma who, eventually, created two quilts from these tiny pieces. Thelma Rodgers, Estancia, New Mexico, c. 1985, 88 x 104 inches. Photo by the author.

PLAIDS
The yellow ties show a roll-your-own smoker
in the family. Josepha Rodriguez, Chamisal,
New Mexico, 1950s, 60 x 67 inches. Photo by
Willi Wood.

CHRISTMAS 1993
Piecing the back and tying from the front can be
decorative as well as time and money saving. Patsy
Bailey and Marian O'Neil, Socorro, New Mexico,
1993, 60 x 71 inches. Photo by the author.

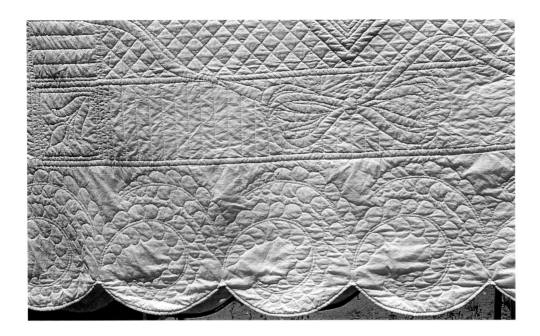

ENGLISH FLOWER GARDEN
This is the back of the quilt, which shows the
exquisite quilting possible among descendants of
homesteaders, people with a bit of leisure, at last.
Karen Earlywine, Silver City, New Mexico, 1994,
88 x 92 inches. Photo by Willi Wood.

Then she pins that first row with large safety pins, ties the row with crochet cotton and moves on to the next row. Tying completed, the remaining three edges are turned in and machine stitched close to the edge. Viola also uses her machine to stitch the name of the owner into one corner.

It is unusual to finish only one edge before fastening begins. The more common way is to make a pillowcase, or leave an even smaller opening than an entire side, in order to turn the quilt right side out. This requires floor space or a trip to the parish hall, where big tables can be pushed together to do the smoothing and stretching before the basting and sewing. Once Elena Sanchez in Questa had an order for a king-size quilt. Where was she going to have room to spread it all out? In desperation, she called her boys to move every piece of furniture out of the living room. The quilt just fit, and, with bricks to hold down the corners, the basting was easily finished.

I learned to consolidate the pillowcase technique with commercial batting when I began to work alongside the women at the old church in Arroyo Seco. Using the big worktables, they had me first tape down the

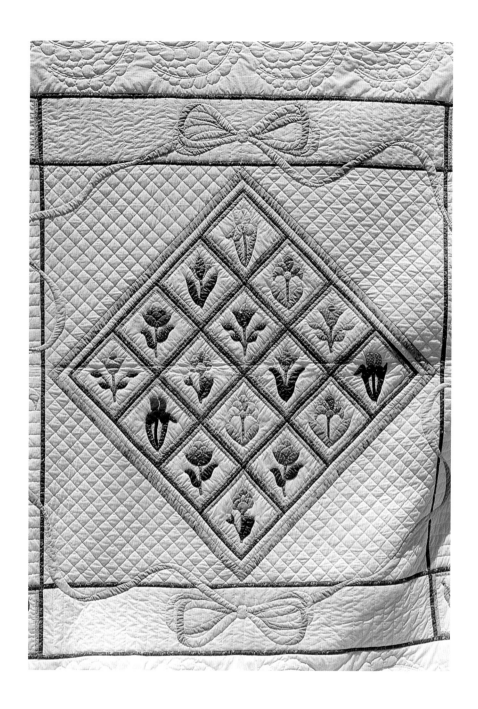

ENGLISH FLOWER GARDEN
Reverse. Karen Earlywine, Silver City,
New Mexico, 1994, 88 x 92 inches.
Photo by Willi Wood.

quilt top, right side up. On top of that went the backing, right side down, and on top of it went the batting. All were basted together just around the perimeter. This is a very frugal way to work because the backing and batting need be no larger than the quilt top. After basting and removing the masking tape, the sandwich is turned over and stitched around three-and-a-half sides on the sewing machine. Turned right side out, it is ready to pin or baste in preparation for tying or quilting. After whipping together the opening, there are no raw edges showing and the tying can be done on a tabletop, or, after some pinning or basting, the quilting done in a hoop.

Quilts quilted in a frame must be bound around the raw edges. A common finish is to bring the backing to the front to bind, or, less often, the front to the back to form the binding. However, most quilters bind with a separate strip, and finally the quilt is finished.

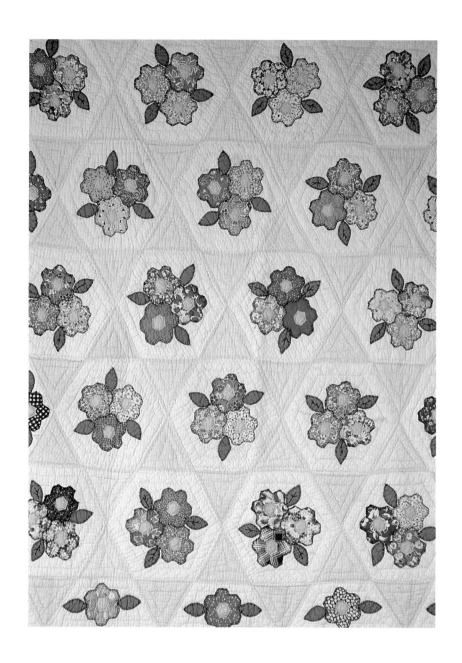

FLOWER GARDEN
An appliquéd flower garden made for her
daughter's wedding when Myrtle was 48
years old. Myrtle Nickolas, Mountainair,
New Mexico, 1945, 62 x 70 inches.
Photo by the author.

WHAT DIFFERENCE DOES IT MAKE?

When the rural quilt survey team arrived in Canjilon, Rio Arriba County, we saw scattered homes and well-tended fields. Canjilon Mountain rises in the distance. We found the general store, the post office, and the elementary school, but where was the senior center? The postmaster had to come outside and point the way to a red-roofed house, our destination.

In all we recorded thirty-eight quilts that morning. When the last camera shutter had clicked and we slumped down into chairs around a dining table, Luvi and her staff had delicious green chile stew and biscuits waiting.

While today most quilt tops, whether patchwork, appliqué or embroidery, are made from newly purchased fabric, cut with a rotary cutter and assembled on a sewing machine, there are still quiltmakers who find satisfaction in preserving the older traditions. After a lifetime of frugality, it is difficult to throw away "perfectly good" scraps, hard not to alter a traditional pattern to fit the amounts of cloth available, and a bit shameful not to have a bit of piecing or embroidery to sit down with when a neighbor stops by.

What do the statistics tell us about New Mexican quilts? My rural quilt documentation project photographed and recorded data on 352 quiltmakers and 848 quilts made between 1900 and 1996 in eight counties, equally divided between northern and southern New Mexico.

Because of a shelf-like geological formation, La Bajada, just south of Santa Fe, New Mexico has, from the earliest Spanish explorations, been divided into the *arriba*, upper, and *abajo*, lower, portions. This escarpment was so daunting for early travelers that it effectively contributed to the isolation of the northern, upper counties. Only because Oñate's settlers (1598), unwelcome in the southern pueblos, were accepted by the northern people of San Juan Pueblo, did they

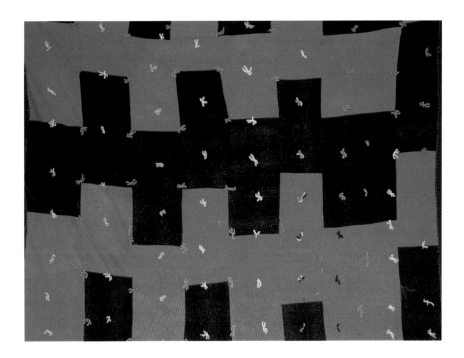

RED AND BLACK
*These are the Peñasco district school colors and
everyone wanted a quilt like this. Josepha
Rodriguez, Chamisal, New Mexico, 1940s,
56 x 42 inches. Photo by Willi Wood.*

decide to establish their colony and church at
nearby San Gabriel. Thus the European set-
tlement of the high plateau came early. The
colony was moved by Oñate's successor,
Pedro de Peralta, in 1610, to a more auspi-
cious location twenty-four miles away and
named Santa Fe. Even today, the predomi-
nantly Spanish, older-style counties remaining
in the state—Taos, Mora, and Rio Arriba—lie
north of La Bajada. San Miguel county,
although east of La Bajada, is included in the
northern counties. The southern counties
represented in the survey are Torrance,
Grant, Catron, and Socorro.

*Driving south, La Bajada becomes more than
a steep hill: it is the division from sagebrush and
trees to sagebrush and sandy dirt. The elevation
drops to only a mile above sea level, the roads are
flat and straight, and the mountain ranges are
far in the distance. Yucca and cholla cacti begin
to appear and the sagebrush is gradually
replaced by mesquite and salt cedar. One can
trace the course of the Rio Grande in the dis-
tance because of the line of green vegetation and
giant cottonwood trees moisture has produced,
but there will be no more tall pines until we
climb back into the mountain ranges of the south
and west.*

Is there any clear indication of a difference in approach to patchwork between the Spanish and Anglo cultures? (*Anglo* is the local term for anyone who is not of Spanish or Native American descent.) Among the Hispanics there is more individuality and less concern to make identical, repetitive patchwork blocks. The Anglos generally prefer the more familiar (to them) formalized styles of quilt design. Prior to 1930, when Anglos were still scarce in the northern part of the state, the survey found only one quilt made in the familiar repeated block motif of the eastern United States, and that one was made by an Anglo settler. Ten of the eleven early block quilts are from the southern counties, by then predominantly Anglo. Today, cultural exchange is erasing these differences.

How many quilts have been forgotten, lost, strayed, or dumped? Viola Silva, after she had produced between one and two hundred old-way quilts for family use, indoors and out, said she could begin to relax and make only about twenty quilts annually to replace those that had been lost or torn beyond repair. Mostly these were bedroll quilts used before the harvesting of San Luis Valley potatoes was mechanized in the 1970s. Before that, to harvest only 1,000 acres of potatoes, less than two sections of land, in ten days, required 100 men. If every man used a bedroll of five quilts, a total of 500 quilts was necessary for the job.

Quilts are lost or destroyed in other circumstances, and it becomes difficult to draw valid numerical conclusions based solely on the quilts that have survived or are too new

yet to be abandoned. Nevertheless, we can get a feeling for the place quilts held and continue to hold in each family.

In New Mexico, once part of the Spanish Empire and a province of Mexico until 1847, the Spanish-Mexican population was originally fairly evenly distributed in between the Pueblo Indian settlements along the Rio Grande corridor. The coming of the railroad in 1880 changed all that, both because it brought an influx of Anglos and because they were distributed along the route of the railroad. Rugged terrain was again a factor in determining this incursion. To circumvent the foothills of the Rocky Mountains, the fabled Atchison, Topeka & Santa Fe Railroad entered New Mexico at the northeast corner and proceeded south through Las Vegas until flatter lands were reached, enabling it finally to turn west above Albuquerque and continue southwest to meet the Southern Pacific Railroad. There was a privately funded spur line for those actually wishing to reach Santa Fe. The north central counties had been ignored.

Briefly, because of the railroad, Las Vegas, the capital of San Miguel County, became the cultural and economic center of the territory. By 1890, with a population of 6,000, it was the equal of Denver or Albuquerque. Its Plaza Hotel was proclaimed the finest in the Southwest; the Montezuma Hot Springs became a tourist mecca, and, for the locals, there was the Grand Opera House and a public library built in the image of Thomas Jefferson's Monticello. Then, in 1900, the AT&SF relocated their headquarters to Albuquerque, and Las Vegas gradually returned to a quieter way of life.

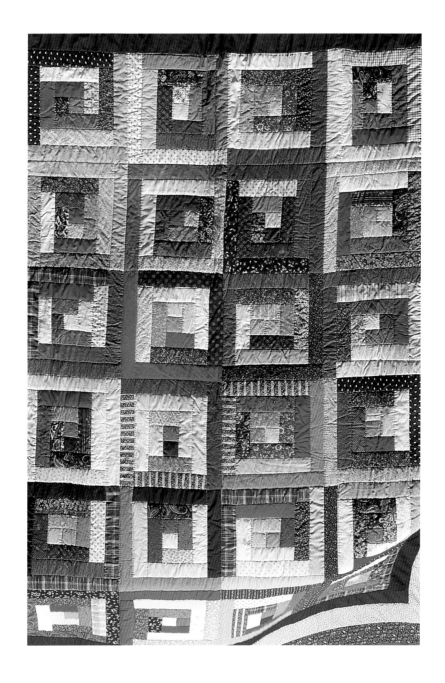

LOG CABIN
"A little black sets things off so-o good." Irene
Chavez, Wagon Mound, New Mexico, 1980,
66 x 84 inches. Photo by the author.

Another town abandoned by the commerce first of the Santa Fe Trail, and later by the railroad is Wagon Mound in eastern Mora County. It is named for a great rock in the shape of a freighter's wagon. Once that rock marked a source of water on the Santa Fe Trail.

In 1993 we drove across the railroad tracks and up the hill into town. On the left is the large consolidated school complex, and on the right, old tree-shaded streets running parallel to the tracks. Down one of these streets we saw some parked cars—a sign of life—and it was, indeed, the senior center. There was a large dining room, a kitchen, and a big activity room with several sewing machines and the boards of the quilting frame leaning in one corner. When in use, the frame is supported on the backs of four chairs. Some of the women work a little every day after lunch on their quilts; others stay only when there is a quilt in the frame that needs their help. Eight women stayed to participate in the survey. The town has a population of 336.

The Great Depression of the 1930s helped to change even the isolated north. Administrators for the various branches of the National Recovery Act arrived to oversee government-funded projects. Folks looking for a fresh start, artists, and "lungers" (persons ill with tuberculosis) all helped to bring eastern quiltmaking methods to all parts of New Mexico.

Comparing the article on New Mexico in the 1891 edition of the *Encyclopedia Britannica* to the 1976 edition helps to pinpoint the changes. In 1891 the hostile Indians had only been subdued for five years. New Mexico Territory was described as a land of opportunity for mining silver, gold, and copper, for

raising sheep where over ten million already thrived, and for lumbering, where an "inexhaustible" supply of timber grew. Eighty-five years later only copper mining remained; gold and silver had been replaced by oil and gas. Cattle grazed instead of sheep. Raising cotton in the south was far more lucrative than cutting timber in the north. The state had become 70 percent urbanized and better known for atomic research than for comforting hot springs.

Two reminiscences illustrate the changing influences. Eva Martinez, recalling the 1940s, said, "A family moved to Ranchos de Taos from Oklahoma and the wife taught me to make this quilt [a Double Wedding Ring]. We even had to buy the four boards to make the quilting frame, which was set up in the living room on sawhorses. We used wool carded from my mother's sheep for the filling. I made several more just like this—gave them all away."

"My grandmother, Petra Padilla, made this Monkey Wrench quilt in Taos in 1935. She learned from her employer. It was the first quilt she made. She used old flour sacks for the quilt back; you can still see the names, Pansy and Dodge City," said Monica Ortega in 1992. The filling is cotton and the quilting is in the fan pattern.

Statistically speaking, 101 quilts made between 1931 and 1950 have survived. Of these, sixty-one are done in fancy block designs, not hit or miss, and twenty-three of these are from the northern counties. They include the Strawberry Block, one of Ruby McKim's patchwork patterns published in the *Kansas City Star* newspaper between 1929

MONKEY WRENCH
Petra was 31 when she made this first quilt.
Petra Padilla, Taos, New Mexico, 1935,
63 x 91 inches. Photo by the author.

and 1931. Ruby McKim's quilt-design column helped to revive interest in American quiltmaking.

Other block designs from the northern counties are: one each of Four Doves in the Window, Courthouse Steps, Star and Diamonds, Lightning, Expanded Nine Patch, Pinwheel, Ohio Star, Philadelphia Square, Nine Patch, Single Wedding Ring, Mexican Rose, Bow Tie, Fan, three Double Wedding Rings, two Grandmother's Flower Gardens, and two embroidered block quilts. One each of Sunbonnet Sue and Butterfly are the only examples of appliqué.

In the south, there are three appliquéd Butterflies and five Sunbonnet Sues. In spite of Sue's popularity, her male counterpart,

Overall Sam, seems never to have made the hit parade in any region of New Mexico. Maybe he wasn't appropriate. As Pearl Spurgeon of Glenwood said in 1950 when she gave her Dutch Girls and One Boy quilt to a friend, "It's my Mormon quilt."

In the south there are also three Nine Patches and two Trips around the World, six appliquéd flower designs, and four Double Wedding Rings, plus five Grandmother's Flower Gardens, four Lone Stars, two Fans, one Rail Fence, one Box in a Box, and one embroidered block quilt.

Can we draw any conclusions from these numbers? Is it even reasonable to assume that these surviving quilts can give us an accurate picture of the quiltmaking scene?

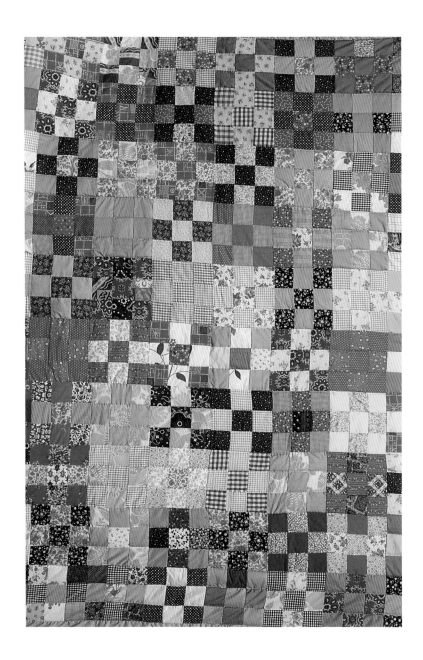

SMALL SQUARES
Irene learned to sew as a child by using her mother's scraps to make doll quilts, pillows, and clothes. Irene Mercure, Rutheron, New Mexico, 1995, 61 x 74 inches. Photo by Willi Wood.

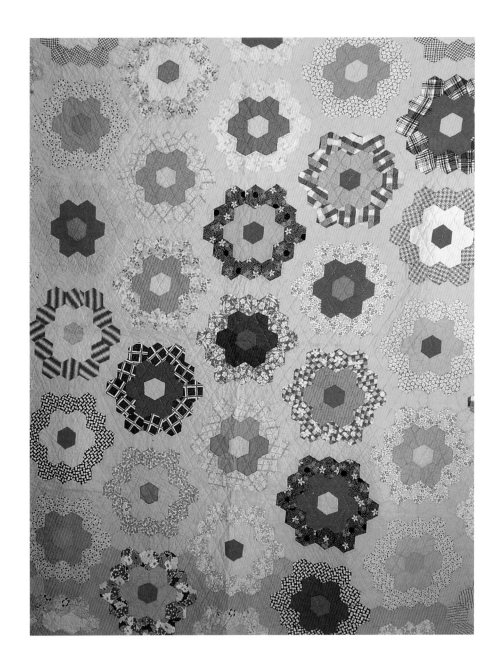

GRANDMOTHER'S FLOWER GARDEN
*"When we had enough scraps we'd just make a
quilt; we carded the cotton for filling and paid
10 cents a yard for a muslin backing." Lorine
Cravens, Moriarty, New Mexico, 1940,
67 x 74 inches. Photo by the author.*

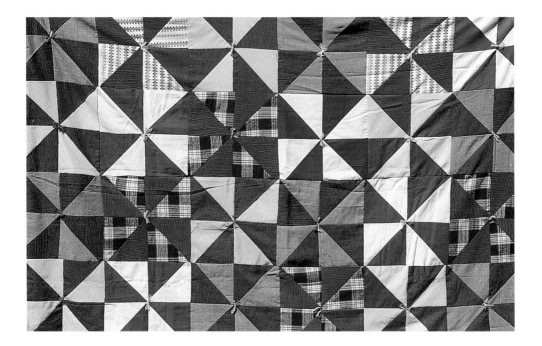

WINDMILL
Angie used some heavy cotton and some polyester
trousers, all good sturdy material worth the
effort to sew up when all six children were still
at home. Angie Atencio, Dixon, New Mexico,
1970s, 55 x 75 inches. Photo by Willi Wood.

Several answers come to mind. Pretty block designs travel quickly from neighbor to neighbor. The owners were prouder and the families took better care of the "fancy" quilts than of the utility quilts. Over half of the quilts recorded to have been made between 1931 and 1950 were "fancies" (sixty-one out of 101). Some patterns such as Grandmother's Flower Garden and Nine Patch, both one-template designs, have always been more popular than others, perhaps because they are more forgiving of random color selection. People with fewer resources take more liberties with their designs.

All areas of the state are frugal. It is the allotment of time that alters from north to south. The Anglo settlers expected to earn their livelihoods from the ranch or business established by the family. The Hispanics under Anglo law were thrust into a new economic system where barter could not fulfill all obligations. The need for hard currency disrupted the family. The wife was often left to run the ranch alone while her husband sought temporary employment elsewhere. No wonder time for quiltmaking was scarce and the need to shorten the process mandatory.

Overall, in New Mexico between 1900 and 1996, our survey found that twice as many quilts were quilted as were tied. However, of the 274 tied quilts found throughout the state, tying was five times more frequent in the northern counties than in the southern counties. "My mother had tied quilts all her life, but she was 76 years of age before she learned to quilt by taking a class at Northern New Mexico Community College in Española, Rio Arriba County," recalled Teresa Sagel.

From Carolyn Gonzales in Amalia, Taos County, we heard, "I learned to quilt from our home extension agent in 1988, after thirty years of quiltmaking. That was the prettiest quilt I have made and the only one I have quilted, and I gave it to my sister."

Again we must take into account the same three factors that have already distinguished the north from the south: the absence of a quiltmaking heritage for the majority of the population, the need for frugality in both time and materials, and the use of an existing cultural item, the woven blanket or serape, as filling.

What about color? In all decades of quiltmaking there seem to be no regional favorites, just personal preferences. Wildly mixed colors predominate because, at heart, these are scrap quilts. This is a land where the older women in the more conservative north still wear housedresses topped with a cardigan to keep off the chill. Pantsuits appear when a younger family member has moved to the city (Albuquerque) and buys for mother and grandmother. Blue jeans are the practical answer to long hours outside helping with the ranch chores. If these styles seem old-fashioned, remember that the philosophy of everyday clothing, like that for quilt fabrics, is recycle, reuse, or hand-me-down. Shoes? Comfy, padded sport shoes are universal.

However, with color, the farther north one goes the stronger the dark and light contrasts become. For instance, in Taos County the appliquéd figures of Tulips and Sunbonnet Sue are attached with a contrasting bold, black blanket stitch. Dark quilts are tied with white, pink, or yellow string, or all three. If environment does influence craftspeople, then the white snow needs to be remembered against the dark presence of the mountains.

Another feature that shows a north-south distinction is the fiber content of the fabrics used for tops and backs of quilts. Wool was used for seventeen of the 848 total quilts; fifteen of these were made in the north. Was there a preference among sheep owners for wool? It is more likely that there was need for extra warmth and durability where winters are long and harsh. Let's look at the figures for denim, which accounts for twenty of the quilts; seventeen of these were made in the north. The north was more isolated, the people were poorer in terms of cash, and it was and is a more recycle-oriented economy. Mixed-fiber quilts tell a similar story. They represent sixty-nine quilts; fifty-one were made in the north. Polyester, frowned on in the quilt literature, tells the same story. Polyester accounts for sixty-two quilts; fifty-two of these are northern. The remaining 679 quilts are made of cotton. Cotton is and always was the most popular, most common, fiber for quiltmaking everywhere in New Mexico.

Statistically there is a clear difference between the predominantly Hispanic-design

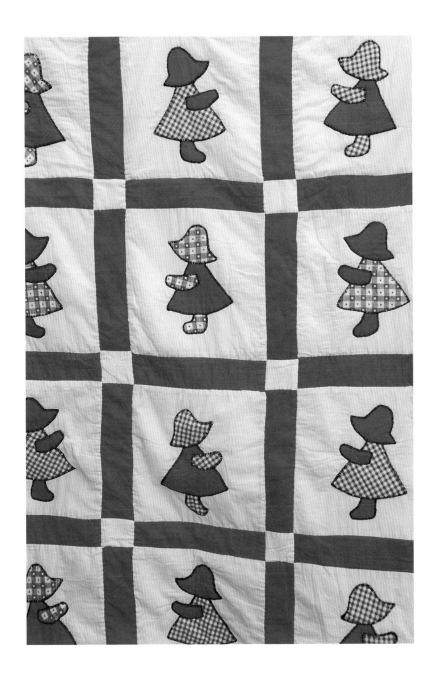

LITTLE DUTCH GIRL
Isabel saved her red scraps for many years to be able to make this quilt. Isabel Garcia, Questa, New Mexico, 1960, 53 x 55 inches. Photo by Willi Wood.

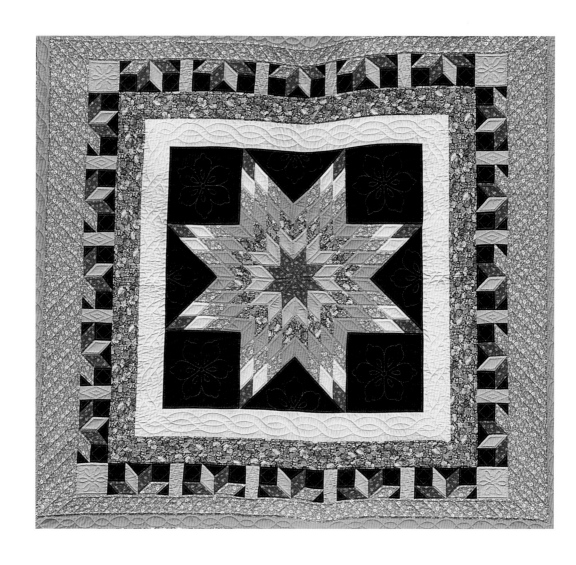

LONE STAR
A Texas family background is often found
with this pattern. Lee Pearce, Silver City,
New Mexico, 1990, 78 x 90 inches.
Photo by Willi Wood.

backings in the north and the Anglo backings from the south of New Mexico. 15 percent of the northern county quilts, and only 1 percent of southern county quilts, are reversible. 11 percent of northern county quilts are backed with large patches from sacking, skirts, or pant legs; this is true for only 2 percent of southern backings. When it comes to whole-cloth backing, either a sheet or minimally seamed yardage, the numbers reverse. Whole-cloth patterned and solid color backings, including muslin, yield figures of 74 percent in the north and 97 percent in the south. This data is taken from a total of 422 quilts in the four northern counties, and 426 quilts in the four southern counties.

Several factors are reflected in these numbers. One is the homogeneity that mass communication has brought to quiltmaking; newer techniques are popular throughout the state. "This Lone Star I made in 1990 was my first use of strip piecing and using a rotary cutter [seen on TV]. Now that's all I use," says Lee Pearce of Silver City. Another factor is the love for pattern and color, which makes a tied quilt all the more cheerful but would almost obliterate fine quilting stitches, the preferred fastening of southern quilters.

The statistics also show us that like the rest of the United States, the national bicentennial brought a tremendous upsurge in quiltmaking in New Mexico. The whole nation was looking to the past and taking pride in pioneer activities. Beginning in 1931 and continuing to 1970, the recorded production of all quilts in the survey per decade averaged fifty-four. In the decade from 1971 to 1980 it jumped to 119 and has been climbing ever since. (Tables and numbers appear in the back of this book.)

Numbers are important because they lend credence to preconceived notions. In traveling through New Mexico I could sense a difference between the two competing traditions, but until all of the data was recorded and compared, I could not substantiate those suspicions. What has become clear is that an Anglo, eastern U.S. tradition dictated rules for quilts that are absent in the quilts made by Hispanic people. The Anglos continued a strong sense of appropriateness, while the Hispanics remained unfettered, experimental, and pragmatic. With time, those distinctions have begun to fade.

Is it possible to distinguish a Hispanic-made quilt from an Anglo quilt? It is about as certain as dating an undated quilt from clues in the fabric. Before the resurgence of quilt interest and publications at the time of the national bicentennial, distinctions were clearer. Generally, a Hispanic quilt freely interprets the one-patch concept so long as the "square" fits. Other tops are appliqués in original interpretations of flowers and butterflies. There is much more originality in the use of scraps of cloth because the pattern is determined only by the maker. Also, since these quilts will be tied, all weights of fabric can be used together. The backing on the quilt is pieced. The filling is anything other than a standard manufactured batting. An Anglo-made quilt is more likely to be divided into repetitive patterned patchwork blocks. The fabrics are lightweight, the filling is carded cotton or a commercial batt, and the quilt is quilted more often than tied.

Both cultures do agree on one thing. If a sewing machine is available, it is used.

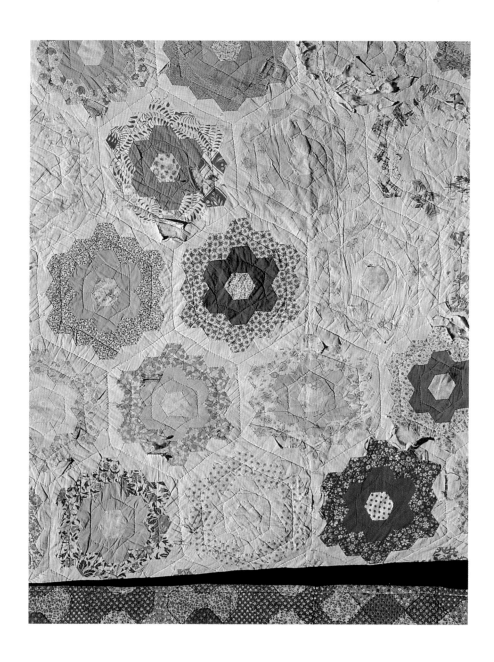

GRANDMOTHER'S FLOWER GARDEN
Assembled on her treadle sewing machine and quilted by hand, this quilt has survived because it was a "fancy." Demetria Roybal, Rio Lucio, New Mexico, 1940s, 82 x 86 inches. Photo by Willi Wood.

Chapter 9

FUN, FRUSTRATION, AND FRUITION

Grant County in southwestern New Mexico includes a large portion of the Gila National Forest. It made a lovely drive through country that opened out onto rangeland; and then suddenly we were in Silver City.

The survey was conducted in a large nursing home. The photography, as always, took place outdoors and the clown of the day was a roadrunner, the New Mexico state bird, who struggled between curiosity and caution.

Leaving town the following afternoon, the landscape became more rugged. We were in mining country. Proof was the Santa Rita open-pit copper mine, ancient and enormous. It stretches forever. It's terraced. The giant earthmoving machines in the distance look like matchbox toys. But with 350 miles still to go to get home that day, we couldn't linger.

We ate lunch in the old general store in Hillsboro. In the summer, tables and chairs are arranged right down the center aisle and the soda fountain is transformed into a small restaurant-kitchen.

Whether for frost or fire, a laugh or a gasp of admiration, quilts have become an essential part of New Mexican homes. "It was necessity—we threw them together because it was cold." Or, "With seven kids (in the 1960s) you got to do something."

Most quilts were so much a part of everyday life that they were usually taken for granted. One whole-cloth quilt, a dark cotton flannel quilted by hand in the fan pattern, was made in Socorro County when the family was burned out. Daughter Klea Montgomery remembers, "She had to make blankets because people were freezing. When Mother died and Dad said, 'How many of these old quilts do you want?' I said, 'Not those old things.' Now I'm so proud to have just this one."

Rose Schmitz came to Mountainair as a homesteader in 1906. She saved every sack and scrap of clothing, ordered bags of remnants from Montgomery Ward, and ran an

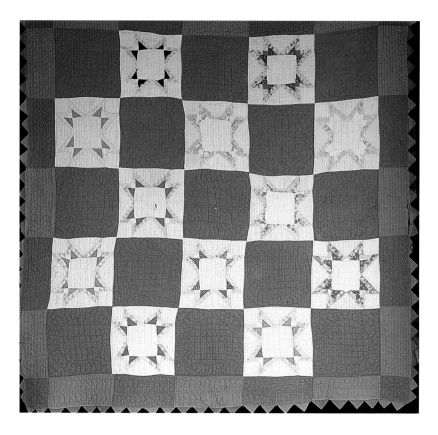

HANDS AROUND
At age 50 Rose could begin to take life easier and indulge
in making fancy quilts with prairie point edging and
Prince's Feather quilting. Rose Schmitz, Mountainair,
New Mexico, 1940, 64 x 65 inches. Photo by the author.

account at Piflon Hardware in order to have enough materials to make the 10 quilts per bed, five under and five over, needed in wintertime.

The Roybal Ranch in Rio Lucio, Taos County, comprised thirteen acres and supported a family of fourteen children in the 1930s and '40s. Mother Demetria had to make everything except coffee and sugar. There was no electricity; she had a treadle sewing machine on which she made *cientos y cientos* (hundreds and hundreds) of utility quilts—four or five on top of every child and older quilts beneath them. Only one of Demetria's quilts remains, Grandmother's Flower Garden, hand-quilted in the 1940s; it was a fancy quilt that was prized by the family.

Isn't it remarkable to think that in the same household the maker of a time-consuming appliqué or block pattern quilt was equally able to produce a tied together, machine whiz-stitched pallet in one day?

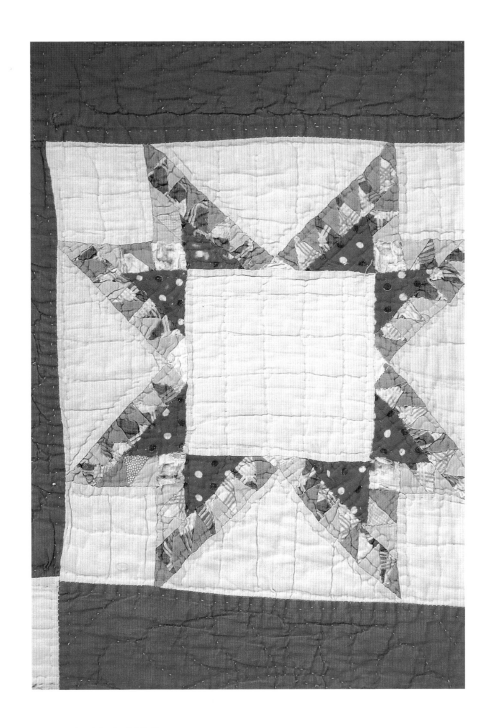

HANDS AROUND
Detail. Rose Schmitz, Mountainair,
New Mexico, 1940.

Even though she probably began to make quilts as a family necessity, the desire for something beautiful and bright in her home seems to have been part of every woman's dream. Sometimes a quilter will only bring prize-winning quilts to be recorded by the survey—blue ribbon winners from the state and county fairs. This is the way she wants to be remembered.

Quiltmaking enters our lives for many reasons. Martha Hatch's first quilt, made in 1983, was made with the help of church friends when she had to move to an empty apartment. Because of chemical sensitivity, everything had to be cotton. She bought three flannel sheets and tied them together.

Walter Henderson made a corduroy medallion quilt at age 20 in 1973, for his bed in the college dormitory at New Mexico Southern University. His grandmother was his tutor.

In Mora County, Gertrude Olivas told us, "My mother had nine children and she taught the girls in turn. When the oldest was married then she would teach the next oldest."

From Rio Arriba County come two memories. Mary Alice Valerio said, "Mom taught me to make *tortillas* and *quiltas*. With her they were both *gordos*, big and plump." And from Ruth Vigil, "When I was 19 [in 1953] Grandma decided that I was lazy and needed to start to do something useful. I started with Grandma's bag of rags and her sugar sacks for a backing. We didn't own a sewing machine so that Nine Patch is all stitched and quilted by hand."

Quiltmaking can be therapeutic. "My granddaughter uses this little quilt just to drag around." Lucyl Adkins of Mora went on

to say, "I would have gone crazy without the quilting—my bad leg and all."

"I once pieced a Lone Star all by hand," said Isobel Griffin. "That was in the 1930s in San Miguel County during the Great Depression, when we didn't have anything else to do. We could get a cup of coffee for a nickel and two doughnuts for another nickel and sit and talk in that cafe all evening, but the owner didn't complain. I guess he didn't have much to do either."

In Socorro County we found a widow, Henrietta Edwards, with seven tops pieced, seven tops in progress, one on the frame, and one in the hoop. Another Socorran, Patsy Bailey, said, "Piecing and quilting are my major forms of self-expression. It just kind of happened. I've even come to think we might have world peace if quilters would put more purple and chocolate brown in their quilts to soothe people down."

"We laugh a lot—the six of us in our Rodarte quilt club. But one time I sat there and cried, and I said, 'I can't do this.' But I did, because they helped me," Faby Romero of Taos County told us in 1991.

Quilts were made for both man and beast. "We used 'em in the buggies—even for the horses," recalled Lucyl Adkins. Shepherds have always used quilts for their bedrolls, and sometimes in place of a saddle blanket. The cowboys call them sugans. "A sugan was made for rough use, a one-patch of material left from the man's pants. The other kind of sugan is a crazy patch. One from my grandfather was just crazy, sewed on to an army blanket." Nancy Miller was speaking of the days on Grandfather Morley's ranch in Catron County.

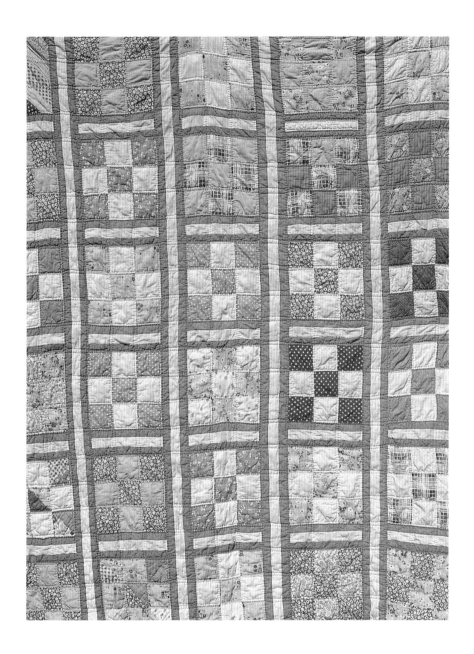

NINE BLOCK
"I was 19 years old when my grandma called me
a lazy thing and gave me her bag of rags and
told me to get busy." Ruth Vigil, Española,
New Mexico, 1953, 64 x 82 inches. Photo by
Willi Wood.

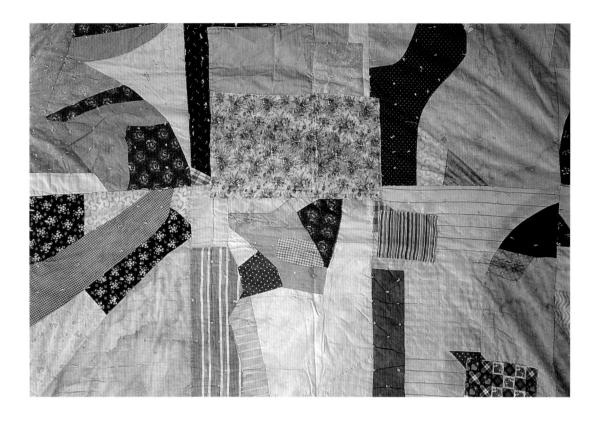

CRAZY SUGAN
Patched but still in use in a bunkhouse on the
Farr Cattle Company Ranch. Maker unknown,
Datil, New Mexico, pre-1925, 70 x 78 inches.
Photo by Willi Wood.

SCRAPS
Nothing was ever thrown away. Magdalena V.
Martinez, Valdez, New Mexico, 1940s, 72 x 85
inches. Photo by the author.

As Eldeene Spears of Taos County said, "Nice quilts are gifts for family members. Tied quilts are used to play in the yard, go to rodeos, go camping, wrap up anything you don't want to freeze, line the root cellar, and immobilize a disobedient child." Her daughter recalled that Eldeene never raised her voice to any of her children, but if one of them had displeased her during the day, for the night a heavy old outside quilt would be pressed down on top of the nice bedcovers.

However, the most unusual idea for the use of quilts may belong to a Valdez, Taos County housewife, Magdalena Martinez. Her husband told the story. "Whenever that wife of mine wanted me to buy her new curtains for the house, she'd show me the bare windows and I'd say, 'What happened to all our curtains?' and she'd say, 'They were so old I had to cut them up to make quilts.'"

Quilts have also been used for trade or to raise cash in all parts of the state. During the transition from lumbering and sheep raising to "cattle or nothing" in the 1940s in Mora County, Annie Fernandez of Ocate helped to bring in cash by making quilts for her daughter to sell in Denver.

Adelia Tapia of San Miguel County used her quilts as gifts and to barter. One quilt was traded to Jerry's Electric in Las Vegas for

CHRISTMAS QUILT
This is the last quilt that Elvira made in the
hope that her children would not forget her.
Elvira Romero, Vadito, New Mexico, 1975,
52 x 76 inches. Photo by Willi Wood.

work, and Adela told Jerry that, in case of divorce, it was his blanket. Jerry reminds his wife of this frequently.

Marcia Goodyear has recently completed a Log Cabin Tulip to be raffled to help raise money for her son—a Silver City, Grant County, high school senior—to go to Australia on the Gridiron Exchange to teach Australians to play American style football.

Is there anything a quilt can't do? They certainly can conjure up memories. In Taos County, Martha Lucero said, "My mother, Elvira Romero, made it the year she died,

1975, because she wanted me to remember her by it—the Christmas Quilt."

"This quilt was pieced by my quilting club in Fort Sumner as a going-away gift," said Neva Turner, now of Quemado. "We were making a hasty departure [in 1981] so the blocks were pieced and embroidered in one day. I had to set it together and quilt it."

There has been a tradition among some Dixon residents over the last thirty years that, instead of a baby shower, they would make a community baby quilt for a new baby. Mothers and older children worked with fabric and

DIEGO'S BABY QUILT

*In the 1970s the commune spirit was still strong in Dixon when the women
decided that, instead of a baby shower, they would make a quilt for each new
child in the group. "We sat down by the river, no clothes to speak of, and
sewed away." Joan McDonald, Nausica Richardson, Marta Chilton, Maria
Chilton, Michael Myers, Jane Kaluda, Eliza Gilbert, Connie Wood, Kate
Moore, Holly Haas, Carolyn Thomas, Joan Carlisle, Sandy Fink, Rosemary
Crawford, and Irene Gilbert, Dixon, New Mexico, 1978, 36 x 50 inches.
Photo by Willi Wood.*

CRAZY
"I wanted a quilt with all my grandkids' names
on it. I made this design as I worked on it. Keep
adding names." Mallie White, Silver City,
New Mexico, 1984, 76 x 72 inches. Photo by
Willi Wood.

embroidery floss, crayons, and paint to create the blocks, a practice that has been carried into the second generation.

Theresa Chavez, now age 82, of Wagon Mound, has made one quilt for each of her nine children, twenty grandchildren, six great-grandchildren and one great-great-grandchild.

Memories are for everyone. As Mallie White said, "Like my Crazy quilt—I just made up the pattern. I recently started to put the names of my great-grandchildren on that quilt. I'm happy with them. Wanted their names on a quilt."

Trash or treasure, a quilt will always have meaning for someone, somewhere, as exemplified in the comment of Mary Alice Valerio, "I give most of my quilts away but I did keep the one that's filled with my brother's army blanket."

We can read a quilt like a book. From a distance it is the colors that attract us. Are the fabrics—the plaids, ginghams, and twills—of old clothes? Is there an abundance of one color that would indicate a uniform? Up close we can begin to see the individual shapes or "words" of the piecing. An even closer look reveals the stitches, the "letters on the page." There are thousands of stitches in every quilt. A gentle smoothing of the patches will reveal whether they were assembled by hand or machine stitching. Sometimes both techniques are employed, suggesting additions or repairs. If the quilt has been quilted by hand, are all of the stitches the same size or did more than one person work on this quilt? When children were included around the quilting frame, their stitches are most likely to be found near the edges, the less visible areas of a quilt when it is spread on the bed. The edge of a quilt is also the easiest area to place between your thumb and fingers to feel the filling. A tear is even better for determining what is inside. This is the way I've discovered old serapes. It is all a record of rural life.

The possibility that no one would come to a survey location has always been in my mind. It happened once. The team arrived after lunch at the large senior center building in Estancia. The supervisor was waiting with instructions on how to lock up and turn the OPEN sign to CLOSED. Suddenly, we five surveyors were in an eerily empty building. We moved with optimism to set up the cameras, station a greeter at the front door, and then we settled down to wait, and wait. The poster advertised 1 to 4 p.m.

It was three o'clock when the only attendee, a woman carrying a big bag, came to the door. Was she a quiltmaker? Well, no. She was an "appreciator," who attended every yard sale in the vicinity. She wanted us to see her four treasures: a Crazy quilt dated 1911; a cotton-flannel and Beacon-blanket hand-quilted Nine Patch; a hand-pieced and tied Log Cabin with a breather strip made from a 100-pound Farmers Best Flour sack; and a Winged Square of faded cottons (hand-pieced and tied with pink crochet cotton). Together we read those quilts up and down and sideways. The names of the makers we'll never know, but the brand of flour they preferred, their favorite colors, their abilities as seamstresses, these are things we could infer.

There have always been memorable quilts in rural life. They conjure up thoughts long dormant in our modern lives. Quilts fulfill

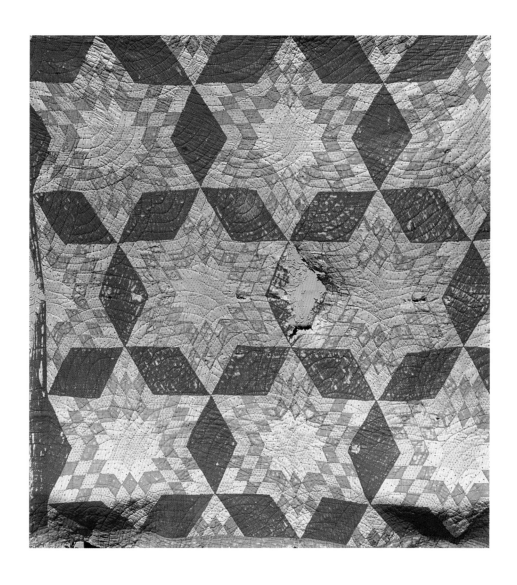

LONE STAR

Helen made this quilt for her husband, who died
in 1920. It has been used in the family, as a quilt
should be, almost to extinction. Helen Adair,
Luna, New Mexico, pre-1920, 68 x 76 inches.
Photo by Willi Wood.

one of our most primal needs, that of shelter. There is a bond between maker and user, whether across months or generations.

A rancher in Mora County was recently widowed. His extended family members were all making suggestions of ways to cheer him up. At last a sister-in-law proposed to buy him some quilts to make the beds look cheerful, and he agreed. In fact, he said, the day the quilts were to be delivered was the first time in months that he actually resented some extra work in a far pasture that made him late getting home that night. Supper had been left warm in the oven, but he couldn't wait. Right to the bedrooms. First one, then another. They were all the same. His housekeeper had spread the quilts backside up on every bed. The next morning as he and she passed on the road, he stopped, rolled down his window and yelled, "What the hell you doin' with my quilts?" Her reply was equally staunch. "Some woman worked days and days. She put her heart into making those beautiful patterns with all the pretty colors. You think I'm going to let the sun ruin her work?"

Today, cultural differences in New Mexico have all but disappeared. The Southwest has become home to retirees who bring even more quiltmaking techniques to the scrapbag. The independent merchant catering to local tastes is gone. Chain stores are tempering our preferences to a universal norm. The same television programs reach every house. Nevertheless, the independent and frugally creative patchworker survives, an undaunted spirit.

It is challenge, ingenuity, imagination, and determination that keep quiltmaking an exciting, ever-changing, and continuing activity throughout rural New Mexico and the entire country.

Appendix:
Collecting Data on
Rural Quilts in New Mexico

Table A.1

CHARACTERISTICS OF RURAL QUILTS IN EIGHT NEW MEXICO COUNTIES

Counties:	Taos	Mora	San Miguel	Rio Arriba	Socorro	Catron	Grant	Torrance
Size:								
Bed	107	71	98	101	140	90	48	74
Baby	1	5	6	11	15	10	2	7
Wall hanging	1	6	4	11	32	1	1	6
Set:								
Medallion	—	5	6	3	25	11	7	8
All blocks	66	37	52	47	69	33	23	31
Blocks/sashing	29	16	27	40	48	35	11	29
Blocks patch/plain	2	11	7	8	22	16	4	6
Strip set solid	3	2	6	3	3	1	1	1
Strip patch/plain	2	3	1	—	2	—	—	—
Crazy	4	3	2	2	4	3	2	2
Whole cloth pictorial	4	5	3	18	15	3	3	10
Composition:								
One patch	52	13	30	22	24	12	4	11
Four patch	—	3	—	1	—	—	—	—
Nine patch	2	3	—	7	11	2	1	1
Cathedral window	1	—	2	2	—	—	—	—
Crazy	4	4	3	2	6	3	2	2
String/strip	4	3	5	4	2	3	2	2

Counties:	Taos	Mora	San Miguel	Rio Arriba	Socorro	Catron	Grant	Torrance
Hexagon	2	2	15	5	6	—	2	7
Patchwork block	22	39	36	28	103	46	26	40
Appliqué block	19	9	17	27	22	25	11	15
Embroidered block	4	4	3	7	9	8	2	5
BORDERS:								
Single	28	15	34	53	64	43	14	30
Multiple	3	20	10	24	64	22	23	18
None	63	39	54	34	55	35	14	36
BACKS:								
Reversible	24	9	12	19	3	2	1	1
Whole cloth plain	34	48	56	50	133	68	35	58
Whole cloth patterned	24	16	20	32	47	28	13	23
Large pieces	14	4	14	14	3	3	—	2
EDGING:								
Back to front	20	29	51	39	40	47	9	25
Front to back	1	3	7	2	5	2	3	10
None (pillowcase)	57	32	14	47	17	6	3	2
Applied binding	16	15	28	29	121	44	36	44
Insert (ruffle/ prairie points)	1	—	—	2	5	1	—	3
FABRICS:								
Wool	10	4	1	—	—	2	—	—
Polyester	6	9	23	14	8	—	—	2
Cotton	67	64	66	92	174	94	47	79
Denim	12	1	1	3	1	2	—	—
Mixed patches	15	4	17	15	6	4	3	5
FASTENING:								
Tied one color	49	23	46	65	18	18	3	4
Tied multi-color	9	9	7	6	3	—	—	—
Machine quilted, straight	9	12	17	14	30	12	7	8
Machine quilted, fancy	2	1	—	9	6	7	4	1
Hand quilted, grid	11	22	19	9	65	18	11	19
Hand quilted, fan	2	3	1	—	5	9	2	2
Hand quilted, echo	1	3	10	25	31	23	28	30
Hand quilted, pattern	1	5	6	5	39	33	13	20

Counties:	Taos	Mora	San Miguel	Rio Arriba	Socorro	Catron	Grant	Torrance
APPLIED DESIGN:								
Hand embroidered	6	6	6	12	12	10	3	9
Machine embroidered	—	—	—	—	—	2	—	—
Crocheted	1	—	—	1	1	—	—	—
Painted	2	2	3	4	1	2	—	1
Hand appliqué	9	2	9	5	13	14	8	6
Machine appliqué	9	2	6	21	8	7	2	8
Hand appliqué and embroidery	3	6	8	3	6	1	—	1
SPECIAL:								
Friendship	1	—	2	5	4	3	—	2
Commemorative	1	4	7	—	1	—	—	—
Cooperative/fund raising	—	—	1	—	3	2	1	3
FILLING:								
Pieced clothing	3	4	5	—	—	—	—	—
Polyester batt	7	20	9	43	136	58	33	44
Wool, carded or batt	2	—	2	—	2	—	—	—
Cotton, carded or batt	15	23	12	13	27	30	12	33
Sheet blanket	25	9	33	13	3	—	—	2
Older quilt	6	3	—	4	4	—	—	—
None	18	12	20	14	12	—	2	2
Blanket	14	5	16	29	2	10	—	2
Other	5	2	8	2	1	1	1	1
DATES:								
1901–1910	1	3	—	—	2	2	—	2
1911–1920	—	—	—	1	1	2	1	2
1921–1930	13	—	2	—	4	12	1	1
1931–1940	12	1	3	3	11	5	2	9
1941–1950	12	8	10	4	7	5	1	8
1951–1960	13	2	7	8	5	1	3	—
1961–1970	17	8	14	10	2	5	2	3
1971–1980	15	21	18	21	22	9	7	6
1981–1990	26	22	22	23	44	25	16	13
1991–1996	3	16	27	47	82	26	20	32

Table A.2
QUILT SURVEY DATA SHEET

NAME OF MAKER: SURVEY DATE:

ADDRESS:

TELEPHONE: PLACE OF BIRTH:

SPOUSE: PARENTS:

CHILDREN:

WHERE DID YOU LIVE WHEN MAKING YOUR QUILTS?

HOW MANY DO YOU THINK YOU'VE MADE?

HOW OLD WERE YOU WHEN YOU MADE YOUR FIRST QUILT?

WHO WAS YOUR TEACHER?

DO YOU WORK ALONE OR WITH OTHER PEOPLE TO MAKE QUILTS? WHO?

WHERE DO YOU GET THE MATERIALS TO MAKE YOUR QUILTS?

WHERE DO YOU GET YOUR IDEAS FOR QUILTS?

 * * * * * * *

NAME FOR THIS QUILT: STYLE: patchwork, appliqué

DATE WHEN MADE: AGE OF MAKER THEN:

SIZE:

MATERIALS FRONT: cotton, polyester, wool, satin old, new

 BACK: flannel, sheet, patchwork, sacks, muslin, print

 FILLING: cotton, wool, poly-batt, old quilt, blanket

 TIES: yarn, string QUILTING: machine, hand

 BINDING: back to front, separate strip, pillowcase

METHOD OF CONSTRUCTION: machine, hand

NAME AND ADDRESS OF OWNER: USE BACK TO TELL ANY STORY